Crossing Boundaries

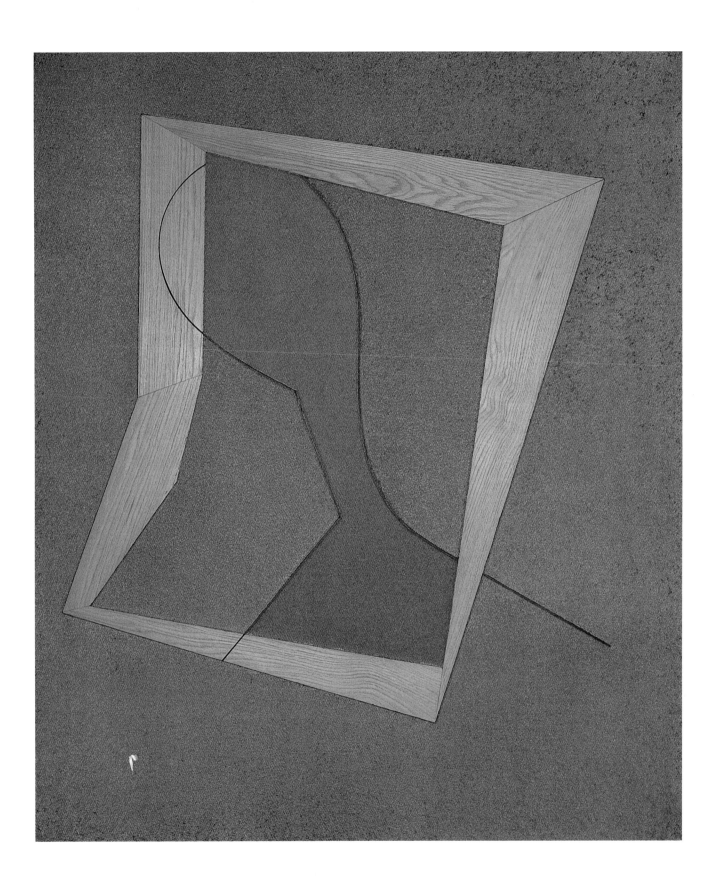

Crossing Boundaries

THE ART OF LEE WAISLER

John Hollander

Gayatri Patnaik

Arturo Schwarz

Margaret Sheffield

Sundaram Tagore

sundaram tagore gallery

in association with

Mapin Publishing

Gallery Statement

Sundaram Tagore Gallery is an international gallery that is mainly devoted to examining the confluence of Western and non-Western cultures. We are committed to developing exhibitions of intellectual rigor, and showcasing artists who are engaged in spiritual, social, and aesthetic dialogues with traditions other than their own. In a world where communication is instant and cultures are colliding and melding as never before, our hope is to create an appreciative audience for art that transcends boundaries of all sorts. Our interest in cross-cultural dialogues extends beyond the traditional visual arts into many other disciplines, including poetry, literature, performance art, film, and music. We will continue to host events that stimulate the exchange of ideas, and we look forward to staging nonprofit exhibitions in the near future.

Contents

Editor
Angelina Stelmach

Photographer
Stephanie Waisler

Acknowledgments

Many individuals have committed themselves to this book, offering a variety of inestimable services without which even our most earnest attempts would have been fruitless. Therefore, our sincerest thanks are accorded to Vivek and Nina Agarwal, Ravi and Virginia Akhouri, Carol Anderson, Daniel and Michael Bénéat, Susan Boray, George Braziller, Barbara Eagle, Kimberly Z. Errington-Moers, Bophavy Euling, Henry and Rita Friedman, Ruben Garcia, Hilde Gerst, Allison Goldberg, Mr. and Mrs. I. K. Gujral, Megha Gupta, John Hollander, Zeva and San Jenkala, Raman and Vinita Kapur, Virginia Kinzey, Keshav and Usha Malik, Michael Mathieu, Kati Pandkhou, Michael and Scarlett Pildes, Lytle Pressley, Scott Robinson, Arturo Schwarz, Bipin Shah of Mapin, Margaret Sheffield, Frederick and Elizabeth Singer, Derek Smith, Witold and Maria Stelmach, Seran and Ravi Trehan and Stephanie Waisler.

Introduction

Over the past fifty years, Lee Waisler has broken many boundaries, both aesthetic and geographic. In the process, he has expanded the language of painting. In order to understand his impact and the language he has created, it is important to look at the cultural climate he has lived and worked in, and to probe the visual psychology that underlies his creative process.

Lee Waisler was born in Los Angeles, California, in 1938. He has spoken at length about the cultural patina of the city of Los Angeles, the denizens of Hollywood, and the influence of both upon his sensibility. Waisler began his artistic studies at the Hollywood Academy of Art at the age of seven, and his profession was in many ways defined by this early engagement with the art of the period. In the 1940s and '50s, when the center of the art world shifted from Europe to America, Waisler was becoming aware of such names as Pollack, Rothko, and Newman—artists who would define the new aesthetic age after Picasso, Matisse, and Braque. Drawn to the writings of Samuel Beckett and the works of Alberto Giacometti and Mark Rothko, he began to produce seductively rich paintings that demonstrated an obsessive interest in surface textures.

His early works, which consisted of sculptures, paintings, and installations, were socially and politically charged with such cataclysmic events as the Holocaust, the civil rights movement, and the Vietnam War—a focus that sharply differentiated him from the California School of Abstraction spearheaded by Clyfford Still. He became a familiar figure in the media, known as an activist-artist and as the creator of such works as *Target L.A.* (pages 28 and 29), *Under the Mushroom*, and *Overkill*—depictions of a city being ravaged by an atomic bomb. His work during this period resonated with socially conscious forms that embraced the issues affecting the planet, though he simultaneously grappled

with more painterly concerns. Ultimately, his aesthetic and social explorations became more solitary, and in the 1970s and '80s he retreated to his studio to focus on formal issues, producing works that possessed aspects of Abstract Expressionism within a Constructivist framework. In a slow, accretive process, Waisler began layering his canvases with thick pigment, sand, gesso, shells, wood, glass, and other organic and inorganic materials, which opened up a wealth of sensuously beautiful compositional possibilities. He has said, "I choose materials for their innate associative values: sand for time, wood for life, black for mystery, concrete for building, light-reflective spheres for their mirror quality. These materials wake both constructive and destructive reactions."

While living near Ojai, California, in the 1970s, Waisler met the charismatic potter-artist Beatrice Wood, Marcel Duchamp's lover, and they immediately formed a bond. It was through Wood that Waisler was introduced to a host of Eastern cultural and intellectual figures, including the philosopher J. Krishnamurti. Conversations with Krishnamurti led to Waisler's belief in the Buddhist construct of constant flux and the Hindu principal of creation and destruction.

Waisler's long study of Eastern culture bore fruit when, in 1996, he was invited by the Indian prime minister I. K. Gujral to exhibit his work at the National Gallery of Modern Art in New Delhi. This passage to India opened fresh aesthetic avenues, prompting him to turn from abstraction to figuration. He was thoroughly transformed by the imagery of India. "The people are seared in my heart and mind," he said. "I cannot but paint humanity, and my attempt is to grapple with the seriousness of their endeavors." This period of figuration continues, another link in a long chain of work that has spanned decades, continents, and styles ranging from the sociopolitical to the abstract, and the figurative.

Sundaram Tagore

The Transparent Hope

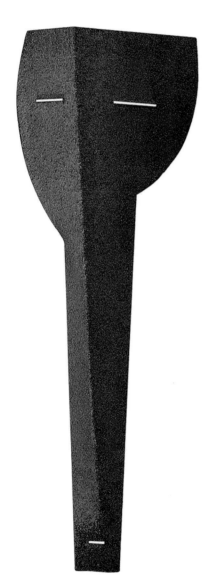

The Green Mask

54" x 19" x 10"; Acrylic, glass, and wood on canvas; 1992

Does one have to recall Heraclitus or Duchamp to speak about Lee Waisler? In order to clarify the grounds of his poetics, must we call to mind ancient speculations that attempt to conciliate fundamental antinomies, to discover secret complementary relationships between the two poles of reality?

Perhaps we should, especially if we believe that "no man is an island," that there are no independent phenomena. Everything interacts with everything else. A drop of water contains the ocean, man, the universe. From this point of view, Lee Waisler's sign is an ideogram, while his work aspires to become a cosmogram. His compositions are a *continuum*: they don't stop with the artist's gesture; they go beyond the physical limitations of the *opus* in order to become a part of that "dream longer than night" evoked in the Talmud.

"From things which differ, the most perfect harmony arises." And then: "There is a harmony of opposite tensions, as of the bow and the lyre." And again: "Life: a name for the bow is life, but its work, death." These three fragments by the poet from Ephesus synthesize the essence of his thought. The semantic ambivalence of the bow—whose meaning is life but whose work is death—recalls the contradictory nature of reality and, beyond this, the fact that harmony arises from the strife inherent in the dual quality of reality.

The Transparent Hope first appeared in *Lee Waisler: Mostra Retrospettiva, 1968–1988 Galleria Civica d'Arte Moderna.* Copyright © 1988 Lee Waisler

Heraclitus came to mind when I saw examples of Waisler's work, in particular *Moon House, Time Tunnel, Storm,* and *Containment.* These four large compositions have one formal element in common: a flexible wood streak, bent more or less markedly into the shape of a bow, in order to confine its dynamism to the surface of the painting.

Are we to see in the piece of wood a pictorial translation of the striking Heraclitean image? The symbolic value of color and of the other elements that recur in Lee Waisler's work seem to support this thesis. For example, sand, concrete, wood, and the color black are classical metaphors for time, binding, life, and death. As is the case with all archetypes, they are ambivalent, and because of their nature they are ideal proof of the ability to overcome opposition.

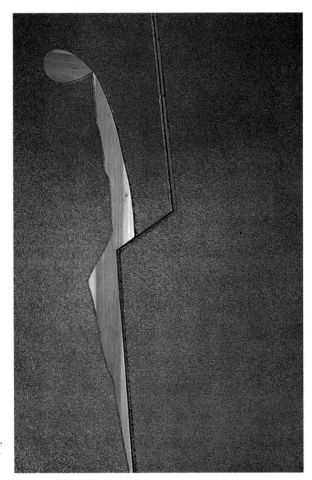

The movement of time symbolized by the dropping of sand is not to be understood in only one way; time flows—as in Lee's works—in both directions. Toward the end, there is death; toward the beginning there is a return to the origins, a regression to the womb.

Wood (the Greek *hylé,* the Latin *materia,* akin to the Hindu *prakriti*) is a synonym for vitality and awareness, as well as for death and ignorance, as is evidenced by the symbolism of the tree, which stands for life as well as death.

Black is both the absence and the negativity of color; in its sum or synthesis, it contains all or none of these qualities. It is the color of death perceived not as a terminal stage but, rather, as a necessary condition for rebirth-regeneration. Black corresponds to mystery, and to the feminine (the Hindu

Ghetto Bench

80" x 56"; Acrylic, glass, sand, and wood on canvas; 1993

Kálí, the Hebrew *yod,* and the Chinese *yin* are black), as well as to revelation and the masculine. The last step in the ladder of knowledge is black (in Sufism), and black is also Vishnu, the virile principle that personifies knowledge.

Lee Waisler's preference for elements with multiple meanings whose allegorical values are, at the very least, dual shows his inclination toward a system of thought that rejects dogmatism and authoritarian principles in favor of what is questionable and undefined. Rather than allow the work of art to be locked up within the limits of a technical or aesthetic category, he prefers the open perspective, the work that is in constant progress. Rather than obey the rules of a system (corporate or formal) and provide answers, he prefers to question and stimulate our innate feelings of transgression.

One must not think that this attitude—not to be confused with agnosticism—exempts our artist from conforming rigorously to his own ethical and aesthetic code. It is no accident that here ethics come before

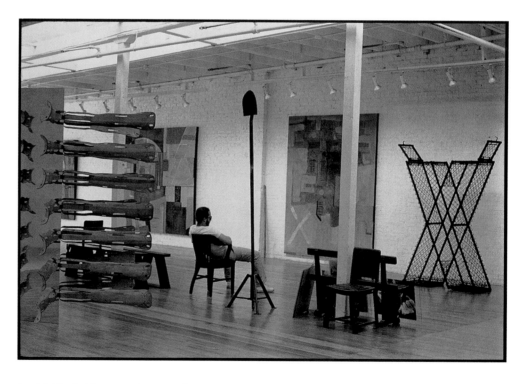

Lee Waisler in his Seaton Street Studio, 1979

form; the former is identified with freedom, in the most utopian sense, and conditions the artistic process.

One has only to look at Lee Waisler's arcane geometries to be struck by the subversive quality to which they testify. For him, as for Marie Jean Guyau, art is a tool for social communication. Such is the power of the artist's belief that his statement becomes a metacriticism of the limits that institutions impose on the human being. Waisler's art is convincing because he understands that his dreams are also our dreams.

Thus it is natural that Lee Waisler's concern is to transcend two classical antinomies: between the artist and his work, and between the work and the viewer. In both cases, he pays homage to very ancient ideas.

At the basis of Hindu aesthetics and art is a vision of the inseparable unity of the whole, expressed by the non-duality of duality (*advaita*). The creative gesture of the artist (in Sanskrit, *karaka*: demiurge) repeats cosmic creation, and within this mimesis he unveils (*kavi*: revealer, another name

Lee Waisler with Arturo Schwarz, Milan, 1986

for the artist) an aspect of the universe and therefore of himself. In order to succeed, he must become the work of art, in much the same way the work of art must become part of its creator. In Dante's *Convivio*, for example, the following is expressed: "He who paints a figure, if he cannot be that figure, cannot even attempt to portray it" (IV: 52–53).

The viewer obeys the same principle of non-duality. If he really wants to penetrate its meaning (and thus its beauty), he must become one with it. This is confirmed by Plotinus, who may have been inspired by a similar Hindu concept: "Any Being who aspires to contemplate God or the Beautiful must first become divine and beautiful" (The Ennead, 1, 6:9).

Marcel Duchamp took this idea to its logical conclusion when he said, "The viewer makes the painting."[1] Lee Waisler fully grasps the importance of this concept. In many of his works, he requires the observer to take an active role, stimulating him/her by the use of light-reflective beading, so that as the viewer moves, the picture gradually changes aspect and color.

In Lee Waisler, I respect both the man and the artist. In times such as the one in which we are living—a consumer society dominated by cynicism, the recycling of past subversion or pointless running after the latest fad—he has the courage of his own convictions and is not afraid to commit himself, even politically. Lee does not yield to market trends or fashions. Remaining faithful to his inner model, he gives us a work of rough elegance, heartrending purity, and balanced harmony.

Arturo Schwarz

1 "Marcel Duchamp Lives," interview with Jean Schuster, *Le surréalisme, même* (Paris), 1:2 (Spring 1957), p. 245

Connections

All but the crudest of illustrations seek to interpret their texts. Lee Waisler's etchings for his selection of Norman Rosten's poems are all, in their way, readings of the verse, readings given in a language other than our own, but a language that we soon begin to learn as we follow its interpretations of the text. A repertory of fields, stripes, incised and raised lines, black tracks across white strips, and a range of pastel tones and their deepened shadows: this is Waisler's graphic vocabulary. In the plate that serves as a prelude to the series, he chooses to "illustrate" Rosten's "Speech Before the Curtain" with his own spoken prologue: a large gray area crossed with promising lyrical lines. From "behind" and "beneath" this metaphorical curtain, the strips of color look like the names in a dramatis personae. This is an introduction to the vocabulary of these etchings, an invitation to come along for *their* "grammar's ride" as well.

As we move through the series, we learn the various roles that color, form, and graphic convention are to play. In *Spain, 1937* (Illus. page 16), a mapping of a world and a vertical picture-plane are yoked together by violence: a scene of barricades, railway tracks, and ways of life, all interrupted by the disasters of war, yields up a lone perspective path into a possible future. It moves upward and ahead toward a minimal horizon,

From John Hollander's preface to Lee Waisler's *Connections*, a limited edition hand-printed Livre Deluxe in the collections of the Metropolitan Museum of Art, the Bibliothèque Nationale de Paris, and the Brooklyn Museum of Art. Copyright © 1976 Lee Waisler.

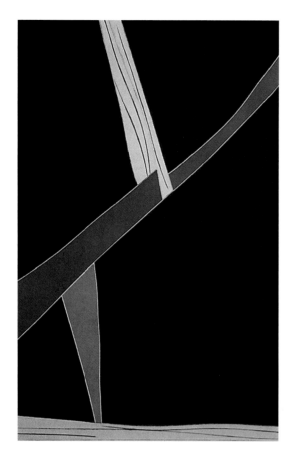

Spain 1937

Etching from
Lee Waisler's Collections, 1976

which, wan and Munch-like, can barely express its presence over and beyond a black field of death colored with the echo of an elegy for the Spanish Republic. In *Caliban*, "the slime, / Clay and color, / Whose shape I am" allows the artist to choose not the earth-red of Adamic clay but a domesticated modeling clay slashed through with the playful lines of joy.

In *Disappearances*, we are returned to a mapping, here, of the convergent and divergent tracks of life itself. The proverbial "line," streams of memory, trails of the consequences of our actions, the wash of receding across engulfing waves—these are the parts played by a purely formal system in this particular graphic "act." Heavy triangular areas of a grayed plum color appear, like the memory of warm flesh that has cooled. With *Song*, we are in a lighter world, free of the interior pressure of heavy triangular forms, and of diagonals that sadden and constrain. Clean fields of gray, white lines, and a stable and pleasantly geometric black strip—a touch of the rich uncertainties of night, rather than the ineradicable ground of death—are gaily bordered by rivers of the poem's "blue air." Here, too, lines sing, rather than exact or condemn; they are the marks of the day's lively light.

In *Growing*, we can see the "serenity and renewal of water," and, more prominently, the "line of vision" itself, both ruled and waved. As in the case throughout the series, the color relationships are always on the brink of parable, and the lesson of development is that all darkness is not the same, that black is kept at bay by the power of consciousness itself. But *Make-up Man* leaves the mappings and plans of anecdote for another set of conventions, in which line and form play their roles in a scene of heads,

masks, and mirrorings; parallels of curvature enact the layers of illusion, the various skins and covers of our life. A dividing and far from indifferent brown stripe makes the strongest tonal decoration.

Flax Pond returns to the interior resonances of fields of vision: the "weight of containment" of the poet's pond is mirrored in graphic containment of a different sort—trim, unmenacing wedges of brown and black frame that by their limits, help define the blue of water and the tracks of various modes of life. *Identity* shows us "the linear day," traversed by the traces of our life; here it is envisioned as a world of verticals, and our tracks, we notice, partake of the fields of experience they traverse. Finally, in *Nativity* we have been brought to white fields of the implicit and the incipient, a symphony of lines of the colors of all but earth, intertwining into a figurative tree. Water and clay and darkness and death move together, not toward the north of a mapping but directly upward, into a reclaimed and renewed kind of pictorial height.

"Poems," said the ancients, "are speaking pictures, pictures a mute poetry." The success of this collaboration seems to me to have given Waisler's etchings echoes of Rosten's poems, while those verses themselves have become shadows of the accompanying pictures. It is hard to be sure which came first, once we have attended to their interrelations. And that is as it should be.

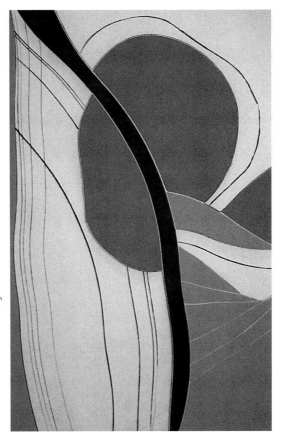

The Make-up Man

Etching from
Lee Waisler's Collections, 1976

John Hollander

Cosmic Radiance in Matter

My strong if not strongest and most pervasive belief

is that life is transmitted by Light.

I see these works as symbols for Life itself.

—Lee Waisler, 1999[1]

Lee Waisler's distinctive artistic sensibility lies in his merging of a personal iconography and aspects of Abstract Expressionism with symbols and religious motifs from India. His dimensional, turbulent surfaces and pulsing, light-emanating spaces have the visionary energy of Abstract Expressionism but possess a unique numinous mystery. Hindu and Buddhist beliefs and symbols enrich the work: the stupa or throne in Buddhism; the Buddhist belief in constant transformation; the Hindu universe's cyclical three-part gyre of creation, destruction, and balance; the life-tree; and the mandala.

Waisler's first influence was Abstract Expressionism and, in particular, Mark Rothko. Certainly the spirituality, the evocation of archetypal images, and the psychic freedom of Waisler's paintings place him in this tradition. Like Rothko and Newman, Waisler's mythic affirmation of mystical content provides the viewer with an experience of "the sacred in the

1. Interview with the artist, August 1999

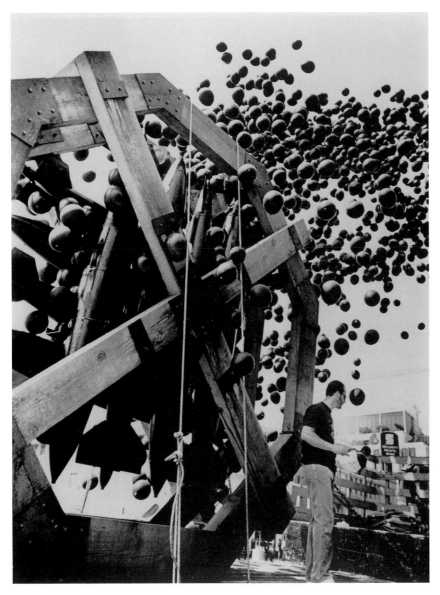

Bomb Cage

Presentation/Protest
Los Angeles City Hall
September 16, 1981.
Medium: Wood, Steel, World
War II bomb casings.

Bomb Cage

Los Angeles, California, 1981

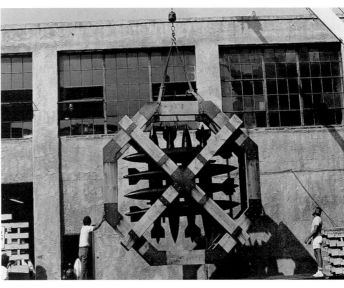

modern world of doubt."[2]

In *Stone Oath*, one of Waisler's masterworks, the textured ground is explosively alive, contrasting vividly—in its myriad colors shifting dramatically on the diagonal—with the silent black void, symbolic of the Buddhist void. The ground itself germinates and evolves before our eyes, conjuring elemental forces in the process of becoming. Depth is created by shifts of tone and color; solid and volumetric areas are adjacent to luxurious and mysterious ones. Expanding circles of pigment and sand—executed with curved wood as well as etched lines—create swirling paths of energy pushing beyond the frame. A spontaneous burst of light gold in the upper middle transmits a sense of present time.

Works like *Trimurti*, *Kaballah*, and *Sky Eye*, with their light-emitting energies and pulsing black voids, evoke an infinity beyond the canvas while their tangible areas and precisely-placed wood simultaneously give the viewer a real scale. *Trimurti*'s bold composition contrasts brilliant cadmium reds and golds, of the stupa form, with a black void. The work is a metaphor for how a mandala leads one from a finite focus—as in meditation—to an awareness of the whole. The painting, in its overall compositional structure and orchestration of movement and color, has a rich gradation of flowing scarlet, ochers, and bricks that is startling against the black void. The wood functions like a drawing to create graphic rhythms, leading the viewer into the vortex structure of the central space.

Trimurti also exemplifies the artist's symbolic use of black, which, since his twenties, has had both philosophical and pictorial meanings. Waisler has been influenced by Samuel Beckett, Alberto Giacometti, and,

2. From *Lee Waisler Retrospective Exhibition*, Ferrara, 1987. Introduction by Arturo Schwarz, page iii.

again, Mark Rothko; all three are distinguished by a use of blackness / void in their oeuvre in an existential sense and also—as writers, sculptors, and painters—by a heightened artistic sense of manipulating the void to express meaning. Waisler's concept of blackness / void, in contrast to a symbol of existential dislocation, is also powerfully brought forth in spiritual terms as a protagonist. In *Trimurti* and *Sky Eye*, Waisler makes black substantial and tangible. In these paintings, black may be simultaneously austere and mute, or volcanic and menacing. In the same work, black may be hard or soft, and penetrable like velvet.

Blood Libel and *Stone Oath* contain historical symbols of the artist's memories of savage acts that have taken place in history, unifying two usually antagonistic painterly traditions. In Waisler's case, this is the archetype-oriented and spiritual Abstract Expressionist tradition and the

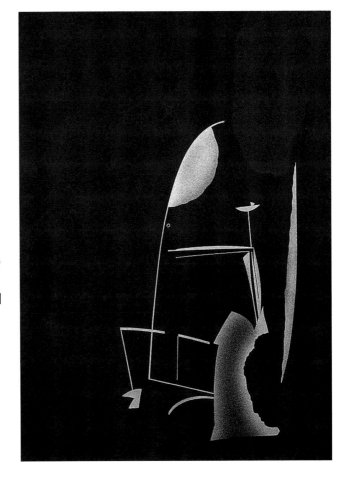

Untitled

1998

30" x 22"; work on Arches paper

sociohistorical tradition. *Blood Libel* concerns an unspeakable anti-Semitic lie that Jews had butchered Christian children—a myth revived by Hitler. The house in *Stone Oath* refers to the homes in which the Dutch hid and protected Jews from death during the war. In these paintings, the artist transforms brutal events. Like Robert Motherwell, Picasso, Kiefer, and Irving Petlin, Waisler does not leave us trapped in the horror of the past. The paintings' exuberant color shifts and pulsing, expansive skies are affirmative; they move us into the same vortex of transformational energies that we experience in a more religious, less political realm in *Trimurti*.

Waisler's work is impressive. First of all,

purely as a painter his gifts are prodigious; his light of transformation can hold its own next to Tiepolo or Turner. Second, in these downbeat and cynical times, his work has a memorable and engaged vision. Third, these works, with their suggestion of the creation myths of biblical narratives, affirm the cosmos as one of ongoing drama and metamorphosis. Waisler conjures worlds of plenitude and belief, fiery spirituality and meditative calm. He communicates that fervor to create a link with the cosmos which Motherwell aptly defined as the "true mysticism" of the abstract artist.

Margaret Sheffield

Untitled

1998
30" x 22"; work on Arches paper

Interview with Lee Waisler
March 18, 2001, New York City

Gayatri Patnaik: *Lee, you were born in Los Angeles in 1938, and studied at the Hollywood Academy of Art at the age of six or seven. Did you know at seven that you were going to be an artist?*

Lee Waisler: I knew there was an obligation that I had to fulfill because my maternal grandmother had said, as early as I can remember, that if she could write or if she could paint, what amazing stories or pictures she would produce. I was the only grandchild to whom she ever said that, so that was the beginning. But I've always been very comfortable with the idea of painting and drawing.

I think it's also a matter of personality. It was very easy for me to entertain people when I was a child. I was a very active kid, and because it was more desirable psychologically to work by myself, I always felt the things that one did by oneself were more profound, and I really didn't do anything publicly until the '60s—as part of a group, which is not how I like to function. I'd rather be the sole producer and control the product, so while I did some public pieces in the '70s and '80s, in terms of my personality I'm suited to be a studio artist.

GP: *How are you influenced, artistically or otherwise, as a result of being in West Hollywood?*

LW: I was in a neighborhood of people who were either extras, stand-ins,

hopefuls, set painters, or wannabes—and it was very much a medieval village. We were in the flats; the Hollywood Hills is where the stars were, literally and figuratively, and everyone was aspiring to be there. And aspiration is, I suppose, a very central part of my work. Everything is possible in Hollywood, and I always had the sense that even though they might not succeed, I would succeed, and to some extent vicariously, for them.

GP: *Is this what one might term a "California mind-set" or a "Hollywood mind-set"—where people are waiting around. . .?*

LW: The people I had as neighbors *were* working. In other words, they weren't by any means derelict in their responsibilities. It's just that their aspirations always exceeded the likelihood of their success. I believe there's a "discovery myth" in Hollywood, and I've even made a painting called *Discovery Myth.* Of course, it's a myth in every possible context, because people who are discovered are people who work very hard, in addition to being lucky.

I never identified with the group who was, to some extent, going to the beach or waiting at the restaurant to be seen or to be heard. Also, my family were workers. Everyone in my family worked very, very hard, and you had to become as educated as possible. You had to work absolutely as hard as you could, because that was simply how human beings had to function. So I was surrounded by people who were very hardworking, either intellectually or physically.

GP: *Was your family supportive of your artwork?*

LW: The female members of the family, and my grandfather, were always supportive, but when the time came for me to go to university my father wanted me to develop a profession that would be lucrative, and certainly art

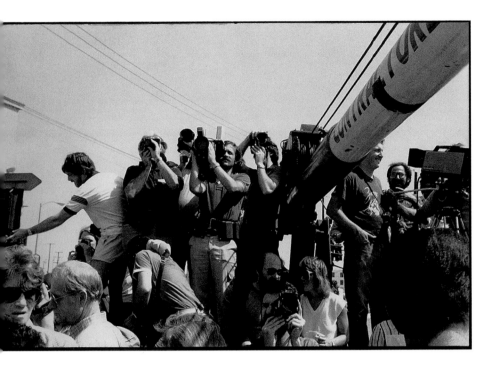

Living Room

Presentation/Protest

Los Angeles, California

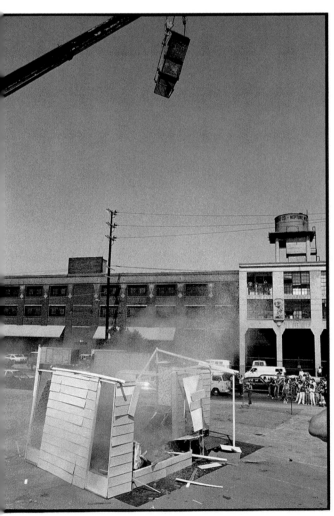

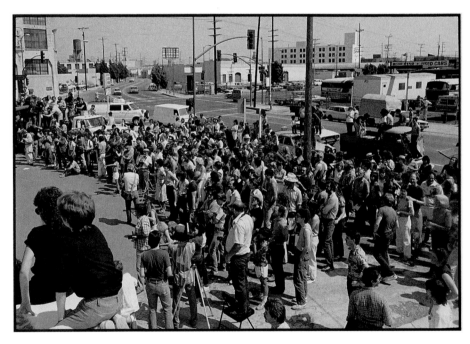

Living Room

wasn't it. So there was that conflict, but once my father realized that this was what I was going to do, he became supportive as well. It took him a while to come around, though. I was probably in my forties when it happened. [Laughs]

GP: *In the late '50s and the '60s, when you were in your twenties, what was the art scene like in Los Angeles, where you were living?*

LW: It was quite diverse. There were a lot of rugged individualists who had taken up the Abstract Expressionist stance, which was really just that—a stance. The myth of the lone artist was very much alive at the time. I remember seeing shows that came from New York which were very surprising to me. I felt there was this lack of cohesion which I didn't understand, but I did understand it in terms of the community, because there was that same sense in the community. At the same time, there's this L.A. or Venice art, which still exists, with which I've never identified—happily, I think. But the L.A. community is and has been very disparate—it's not cohesive, and it's rather cliquey.

GP: *Tell me about your first exhibitions.*

LW: The first one-person show I had was at the Rider Gallery, on La Cienega, and the man who ran the gallery was a good German Expressionist draftsman. He had a great fondness for graphic work, and I had just started doing prints at the time. I showed him my work—in those days you didn't show slides, you just took your work in your hands—and he said, "This is great! Let's show it," and that was it. They were pictures dealing with social concerns—the Brassero movement was very much in everyone's consciousness at the time, so I had pictures of Brasseros—and then there was another picture, a rather Abstract Expressionist colored etching. I also

had a picture of a woman on a prison bus whom I had seen looking down at me as I was driving my topless car one day. She was angrily looking at me and I felt ashamed of my freedom, and I did a picture of this woman. Then there was a series on the crisis in Biafra, which was occurring at the time.

The works were figurative, and there were abstract elements in them. The fellow who ran the gallery told me that he thought they looked like they were produced with a butcher knife, and he was very drawn to them. I was quite complimented by his reaction.

GP: *In your art, it seems clear that you've worked with an awareness of the Holocaust and that being Jewish has informed your work. Can you speak about this?*

LW: I always think about what some of the poets wrote immediately after—and not so immediately after—the Holocaust, in trying to think about the question "How do you produce art in the shadow of this calamitous event?"—and why, of course. And it is a huge responsibility that I feel. Additionally, there's so much that's been said and produced that it's difficult not to be overly influenced by some of these aspects. So I use it as an underlying subject, but I feel that sometimes it's important—in order to show the real power of it—to understate it, and not to think of it as I used to, which was as my primary subject, or raison d'être.

Right now, I'm thinking of an idea that came to me in a dream—the words in the dream were the architecture of the Holocaust. The idea was that the actual remaining elements—these sacred monuments, fence posts, passageways, floors, and windows in the camps—have retained a kind of horrible information that I'd somehow like to experience. So I've begun making drawings of these elements and seeing how they're going to evolve. It's the idea that walls really do have ears, and it's very appealing to me to be

able to look at things which those people who were destroyed looked at. I also feel it's important to find the universal aspects that these experiences suggest, because it's a universal experience. It's not only that the Jews were killed; it's that human beings were killed, and are being killed—and that's what I'd like to address further.

GP: *I believe you saw Andy Warhol's paintings for the first time when you were around twenty years old. What passed through your mind the first time you saw them?*

LW: I thought, "These are audacious fakes", and I thought, "How dare he!" Still, I was very impressed, and I couldn't understand why they were being shown, for Los Angeles, with so much fanfare. And I was offended as well. I have since learned that being offended is a high compliment for art, but when you're that age and had worked the way I had worked, I didn't see it coming at all. On the other hand, I felt that the responses of Rothko, Pollock, and Clyfford Still were very appropriate to the calamities of the mid-twentieth century. I thought that was very fitting and appropriate, but not so with Warhol.

GP: *What do you think differentiates you from the other California-school artists? Also, when did you diverge from the California school of abstraction, spearheaded by Still?*

LW: I never even felt that I was a Californian, let alone a California artist. So that was probably very attributable when you think about it. And although

Target L.A.

Los Angeles, California, 1981

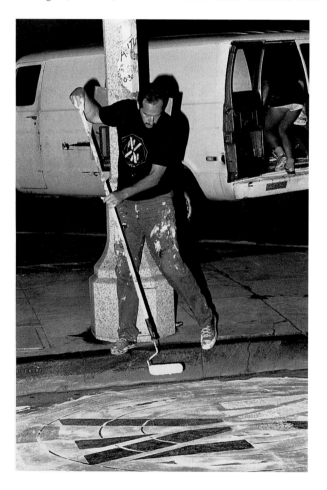

I watched what was happening peripherally, the people who interested me most were not even in California, with very, very few exceptions, so I never had to break away, because I was never connected. I still live there, and there are aspects of living in California, obviously, which are excellent for artists, but I never identified with it as my artist's home.

Target L.A.

Proofs, 1981

Lee Waisler with Beatrice Wood at the opening of Waisler's Garden Show, Los Angeles, California, 1993

Lee Waisler and Beatrice Wood met by chance in Ojai, California, but they were to forge a relationship combining their personal and artistic respect for each other that spanned more than three decades, until Wood's death at the age of 105. They are pictured here at the opening of Waisler's Garden Show, Los Angeles, California, 1993.

There's also the essential frustration inherent in being an artist. You're constantly observing. You're observing the crowd, but you're not ever in the crowd. You're always an outside spectator and the moment you become part of the crowd something abhorrent happens that makes you feel like you're being dishonest or disloyal with yourself.

GP: *It sounds as though being an outsider is actually very necessary to what you do.*

LW: Finally, at this late age, I realize that's the case. But to me it was just frustration and angst for years and years. I couldn't understand why I wasn't part of the scene. Of course, I should have had some clues from the artists I

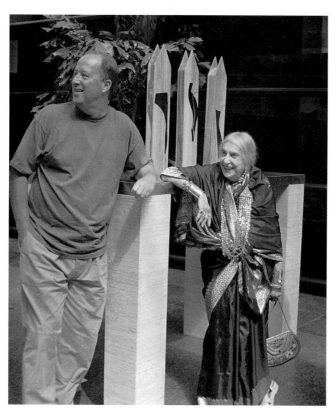

had been so impressed by. Most of them were extremely isolated, and they maintained that isolation to their—and our—advantage.

GP: *I'm intrigued by your Hindu-Buddhist philosophical and artistic influences. Can you tell me about your relationship with Beatrice Wood, whom I believe you knew for twenty-five years, and also Krishnamurti?*[1]

LW: I actually met Beatrice by mistake one day. I had an assistant who was making ceramic twelve-inch dishes which weighed thirty pounds, and I said, "We have to find out

1. J. Krishnamurti, a twentieth-century philosopher, was a selected figure involved in a theosophical movement. His beliefs include the principle "Truth is a pathless land," in which he rejects dogmatic approaches and affirms the idea of a collective human consciousness.

how to do this properly," so we went up to Ojai, which is an hour- and- a-half from Los Angeles, and met Beatrice Wood. She was 78 or 79 at the time and had many years to live. She lived until she was 105.

My connection with Beatrice, interestingly enough, was through Duchamp. She had her drawings spread all over the floor of her studio—old drawings, current drawings, exquisite pieces—and I was very impressed. I was unimpressed with her ceramics, as a matter of fact, but I liked her, and I liked her drawings. I said to her that these were phenomenal, and asked why they were on the floor like this, and she said that she was going to get rid of them. I thought, "That's interesting," since some of them were dated from 1915 or 1920. I told Beatrice that they should be taken care of, and put in archival folders, and maintained properly. And she said, "You can have them." This was the first time I'd met this woman, and she said, "Just take them all. I don't want them." Beatrice made these grand gestures very easily. So I picked them all up—there were three hundred or so—and I took them all back, and for two weeks this same assistant and I worked to put them into folders and to clean them up a bit. We brought them back and made an exhibition of her work, and Beatrice loved it. She said I was the only one since Duchamp who had anything good to say about her drawings. She told me to keep some, and I kept around ten of them. In the intervening years, I bought some drawings, and she gave me drawings, and we used to exchange Valentine cards that we had made—I have a few of those left.

Beatrice was a highly unique individual, and very much affected by India. She had followed Krishnamurti for many years, finally going to India in the early '60s and meeting R. P. Singh, who was working for some organization there. By that point he'd been with her for about thirty years. Beatrice used to show me pictures of India and talk about her experiences there. I had, of course, some intellectual knowledge and knew a few Indian

people, but Beatrice really focused me on the real India—on the accessible, real India.

GP: *What did you find significant about Jackson Pollock's art in personal terms?*

LW: I feel that, like no one else, Pollock had a sense of prescience about the consequences of the two holocausts that occurred in the center and towards the end of his life: the American dropping of the atomic bombs on the Japanese, and the Holocaust. He had a sense of this explosion which seems to have been related in his work in very graphic, pictorial terms. I never saw those paintings as being abstract; I saw them as being succinct, very precise, and to the point. I don't know that this was a conscious effort on his part, but, to me, if an artist can reflect his time that specifically and that well, he's absolutely extraordinary. So that's what I loved—and love—about Pollock's work: the immersion of the reality of his experience, which was, like mine, so completely separate from the actual experience. It was that capacity for expression that made all young artists, who had any sense of what was happening at the time, say, "This man has shown me the road to freedom. This is how I can be free to be whoever I have to be, and I have the freedom to fail as well."

We speak of Pollock in heroic terms, and his work, of course, had a heroic scale, but I feel him much more in very personal terms. I know what it is to have survived, to be spared, to have witnessed, and to have communicated with people from the actual experience—and the feelings issued from that are deeply important for the artist. Again, we're the spectators; we're the reporters.

GP: *You've commented that Rothko's painting is "the highest form of spiritual*

art that has been produced in the United States." That's quite an accolade. Why do you think that?

LW: I find that there's a spiritually arresting, almost paralyzing sense of darkness which comes as a consequence of Rothko's capacity to deal with light. But I think it's the darkness which is so powerful, and I must say that since my first experience with Rothko, I have prepared my canvases always in black, not in white. I think that everything issues from black; everything returns to black, and I don't think black is depressing. I don't think Rothko's last paintings were necessarily so much prescient of his suicide. I just think that he got very close to reality, and it could very well be that he knew his work was finished, in addition to the other factors, of course.

Mona

60" x 60"
Acrylic and wood on canvas,
2000

GP: *I've heard that in some ways you live an almost monastic life. Is that true?*

LW: I'll tell you what's happened. You're born and you look around, and that birth can be becoming an artist or becoming anything at all. You take a lot of things in, and for some people it's early and for some people it happens later, and you do a kind of introspective diagram of yourself which can take years and years to do. That introspective diagram is what I do, and not because I think that I'm the most interesting person in the world. But I do think that I'm the most interesting to myself, in part because I'm sensitive to what I believe I've seen, and I'm sensitive to the need to express that.

After having gone to many museums and having seen a lot of work, I

really have to say that I'm interested in the process of my own response, and I have been for fifteen years. And I have, as a consequence of that, probably given the impression of being more and more isolated or monastic, which is perhaps a nicer word. It's a matter of the constraints of time, but if something interests me, like a Giacometti show, I'm going to get to it. But the truth is that I'm not out there looking that much. I don't know if I like the way this necessarily sounds, but it sounds like the truth.

GP: *Can you talk about the significance of your sojourn in Holland?*

LW: I went to Holland to have an antiwar sculpture produced, and that piece was made in a little village called Ootmarsum in eastern Holland. It is, very significantly for me, five kilometers from the German border. It's a community which, at that perilous distance, protected Jewish families—one in three households were involved in this action.

It's an incredibly heroic period. I got there, met the people who were ultimately to construct this inflatable mushroom structure, and I just wanted to live there and work there. I ended up buying a small converted studio and lived there, off and on, for six years. I showed at the Rijksmuseum, and various other places in Holland, and got a very interesting sense of what it is to be mute. You're there like a child; you can't speak a word of the language and are literally drawing pictures for a year to buy peanut butter before you can speak the language. But the war is still very much in evidence there— you can go across the border and see bunkers and live close to where the Battle of the Bulge was fought, and there are buildings with bullet holes, and the scars the people have are very much in evidence as well. So I wanted to be there for that.

GP: *Did you formulate the idea of the* Under the Mushroom *sculpture in*

Europe or in the United States? And how did you start thinking of it in such massive terms?

LW: I thought of the sculpture when I was in the United States, and it actually came to me in a dream. There's a lot of very large-scale sculpture in L.A, and I dreamt of the whole thing except the title. I'm standing under a tree, which I later identified as the tree of life, and it became this huge black mushroom cloud which floated down on me. I was terrified and exhilarated, and I woke up and started doing a drawing of a mushroom and thinking, "What's the practicality of creating this thing?" Anyway, I designed this thing and the American company able to fabricate it turns out to be very reactionary, but this man in Holland says to me over the phone, "Fly over tomorrow." The next week I flew over, showed him my drawings, and he said, "Sure, we can do this." It was a huge project; we had to make the material, and we had to develop a certain kind of cord, but we did it, and it was quite effective. It looked like someone had cut a vast mushroom form out of the environment. A black hole into the sky.

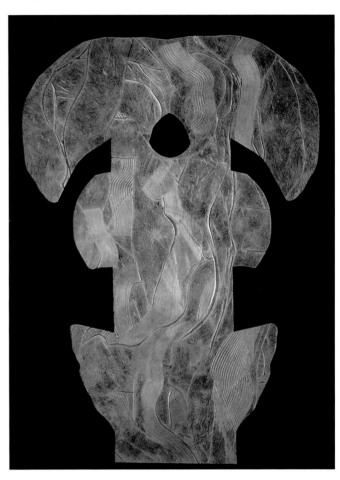

Mushroom, 1981

108" x 84", Acrylic on canvas

GP: *Are there other sculptures or artwork that first came to you through your dreams?*

LW: Yes, but most of them I haven't been able to do. They're either too expensive or too impractical. I had a dream about overkill at one point; I was suspending a car above an egg, which was in a chalice, and then the car dropped onto the egg to demonstrate the overkill capacity.

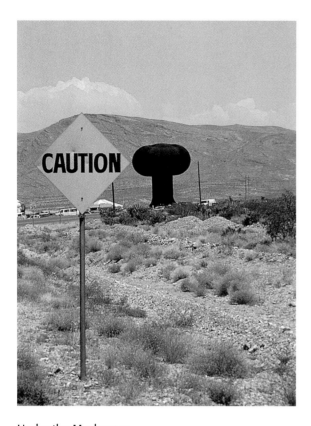

Under the Mushroom,

Nevada Test Site, Nevada

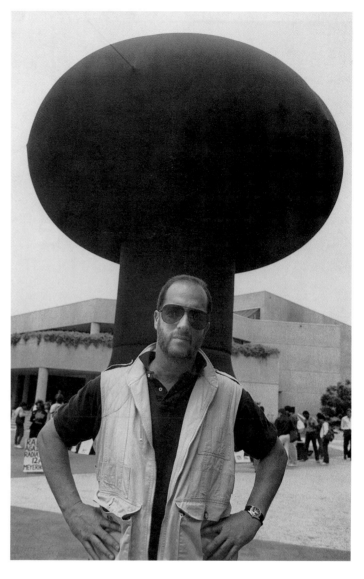

Under the Mushroom,

Presentation/Protest. Berkeley California, 1986

"Rare for an artist, Waisler is as connected to his outer, political world as he is to an inner reality. Since the 1960s, his work has consistently included sculptures and paintings with anti-war and anti-nuclear themes. *Under the Mushroom* (1982), an air sculpture five stories high and fifty feet in circumference, was first exhibited in front of the Museumplein in Amsterdam, adjacent to the American and Soviet embassies. The date Waisler chose, August 6, 1985, was the fortieth anniversary of the U.S. bombing of Hiroshima. During the next year, Waisler raised the sculpture on the campuses of UC Berkeley and UCLA; the work was exhibited yet again on May 31, 1986, at the Nevada test site.

That Waisler considers works like *Under the Mushroom* public is confirmed by their arrangement in connection with the media."

–Margaret Sheffield, from her article "Lee Waisler's Political Work."

GP: *You consider some of your works, like* Under The Mushroom *and* Target L.A., *[Illus. on pages 28 and 29] to be public because you arrange them in connection with the media. How do you generally perceive the media in relation to your art?*

LW: The media can be a friend and, at other times—I don't know if you're familiar with the L.A. *Times* incident—a great enemy.[2] But, if you're clever, you can make it into a friend. My experience with the media has been very good. I've found that the people who run the cameras and carry the props are very receptive, interested, and intelligent about these things. It's the editorial and corporate people who make it a little more difficult. Someone told me, when I did the L.A. *Times* demonstration, to be careful and that they might want to put me on Johnny Carson. This psychoanalyst told me that in Russia they'll put you into the Gulag for doing this, but in the United States they'll put you on Johnny Carson. And he said, "The effect is exactly the same." I was actually called to go on Johnny Carson, and I didn't, because there's a tendency to trivialize these things and to control them in that way.

GP: *Were you at all nervous about what dumping manure might do to your career in terms of censure in the art world?*

LW: No, I didn't care about that. I knew that it was the right thing to do, and I was exhilarated by the idea that, for once, the artist gets to critique the

2. In May 1981, Lee Waisler responded to what he felt was a thoughtlessly written review of an exhibition of his paintings by an art critic from the *Los Angeles Times*. After characterizing the works as "vacuous decorations" despite the fact that they were overtly political, the critic received some critique of her own from the artist himself. During the lunchtime rush, Waisler deposited several tons of horse manure on the steps of the L.A. *Times* building, straddled it, and commenced a protest that attracted a torrent of media attention. Shouting, "It's nice to clear the air!" from atop the mound, Waisler affirmed his belief that "the only way to break the bonds of control and feeling of helplessness is to act."

critic. I wished it had gone to the legal areas, which it didn't. They were very clever not to have me arrested, so that the First Amendment considerations were never an issue.

GP: *How did you deal with your celebrity status, since it catapulted you both nationally and internationally?*

LW: It was fun, but what I found, as I was being interviewed, was that they wanted to know things like what kind of clothes I liked, what kind of car I drove, where I lived, and they photographed my studio. Ultimately, for me it got old very quickly, although I was able to raise money for other artists and to speak for other concerns fairly effectively. I saw that I had to go back to the studio because this was not going to be the career for me. What was extraordinary was that I had a sense of the power, in terms of being the focus of the media, the likes of which you don't understand unless you've experienced it. I live two blocks from Twentieth Century Fox, and it's an interesting place, but until they're focused on you, you have no sense of the enormity of it.

GP: *You demand an active viewer, and have said that you want people to dig for the meanings in your work. Your sculpture* ASH WHEEL, *for instance, is literally activated by the viewer. Why is this so important to you in your work?*

LW: Apart from a visual exchange, if a physical exchange or investment of energy can occur from something that I've created by the viewer or participant, then something muscular happens. Something tactile happens, and I think viewers are genuinely affected by that kind of experience.

I'm interested in transformations, and in alchemy, and in the capacities of people to have experiences absolutely out of their expectations. I liked that the transformational aspect of *Ash Wheel* was that those prongs,

on the ash wheel, were torpedo-case openers and here they were stirring ash. And furrows are made as a consequence of the movement of the wheel, so there's a real transformation in the viewer who is performing that transformation. That's why I use, for instance, light-reflective material, so when the viewer is in position A, the painting appears to be different from another position, so that important sense of participation is elevated.

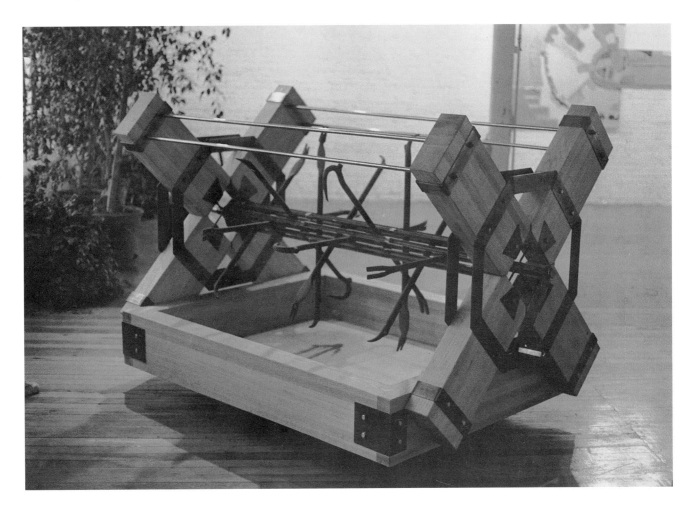

Ash Wheel, 1982
48"x 72" x 72", 1982

"Sculptures such as *Ash Wheel* resemble extravagant machines for death and function as ominous, potent warnings to end America's flourishing industry of death. *Ash Wheel*, fascist both in size (48" x 72" x 72") and mood, is structured from immense oak beams and contains a sinister base of ashes. Above the base, one sees a large, rotating axle affixed with crowbars used in World War II to rip open torpedo cases. When *Ash Wheel* is activated by the viewer, the crowbars cut into the ashes and disperse them with a chaotic and random violence through the atmosphere, a metaphor for lethal nuclear waste."

—Margaret Sheffield, from her article "Lee Waisler's Political Work.."

GP: *You've said that you choose your materials for their "innate associative values"—can you speak about this in concrete terms?*

LW: Wood is a material which is associated with shelter and with life, the tree of life, so I choose wood if I'm interested in that galaxy of ideas. Earth is earth. Sand symbolizes time, and glass for light. So, if I'm painting light and I can paint with light, I enhance the possibility of communicating my belief. I think there's a level of appreciation that my work receives, since these are rather simple clues as to what the work's about. I'm not interested in just being abstract. I think that for everything an artist does, he or she has to have a very good reason and a meaningful instinct.

GP: *Did you come to a conscious or unconscious decision to use, for instance, sand as a metaphor for time? In other words, did you simply find yourself doing it one day, or had you made a conscious decision about it first?*

LW: I work near the beach and needed to thicken my paint, so I got some sand and started mixing it with paint and, of course, the texture was changing. One day, I used a whole box and I started to think, "What does that symbolize to me?" And that's how it came to me.

The idea for a piece of work is a seed. It's a skeletal concept, and a drawing is a skeleton—or an armature, in sculptural terms—for a work. Like most painters, I would paint the general idea of the painting in charcoal, then start painting and developing the figure, giving it volume, etc. And then I decided, if the drawing is really good, why not make it such that it can't be altered quite so easily? Do the drawing and then laminate wood to the drawing lines and then paint and forget all about the drawing. Of course, the wood is either a half inch away from the canvas or perhaps a quarter of an inch, and after the paint is applied I sand the wood and bring it back to its original state. So, like a lobster, the shell or the skeleton is on the outside,

instead of on the inside.

You can't fool yourself, because I can paint like hell—I can amuse myself, and it's beautiful, but it doesn't mean anything at all. What's the original idea, and how true am I to the original idea? And that's what the wood is about. And later I thought, wood has symbolic meaning as well, and I began to use it in the drawing phase for its symbolic content, but, you know, inspiration comes from work. Work does not come from inspiration—you work and so you become inspired.

GP: *Light is an important aspect of your work, since one of your strongest beliefs is that life is transmitted by light. At the same time, black is also incredibly significant. Can you talk about what black symbolizes for you, and also mention any artists who might have influenced you in your use of black?*

LW: I believe in the unity of opposites. White and black are opposites—apparently, seemingly. Black is the cauldron—that container that all possibility issues from. And there's a psychological blackness in the work of, for example, Samuel Beckett and Alberto Giacometti; but that blackness, very interestingly enough, functions because it is the opposite of their real belief. They say, implicitly or explicitly, that it's hopeless, and then they keep on working. They go on trying. God is dead, but there must be a God.

That mind-set to me is just incredibly inspirational, and that's the symbol of blackness that interests me. Blackness is a technical device that I use to get me going on something. It's the first thing I do. My eyes are closed, I'm thinking about something, I'm feeling something—it's black, and I begin working.

Light is the constant interest of artists forever, and I do still feel that life, and this isn't an original idea—it's in the Kabbalah and in all the major philosophies—that life is transferred and transmitted through light. It is

through light that we see each other. I can look in your eyes because of the light that exists between us.

GP: *India has influenced the work of painters like Matisse and Clemente, and you yourself have lived in, been influenced by, and created art in India. Why India— and how has India affected you and your work?*

LW: Lately, in Western culture, the idea of the accident and the idea of correspondence are being reexamined. I got to India in physical terms because of Beatrice Wood. Beatrice introduced me to I. K. Gujral, who came to my studio and said my work would resonate well in India. I thought nothing of it, but that it was a sweet comment from a lovely man, and when he became the prime minister his wife asked me to illustrate some of her poetry, and then I was in India.

I had Indian friends, but when I actually got to India nothing prepared me for it. I dare say, no Westerner is ever prepared for it. India to me was a comfortable challenge. In India, the entire country, to me, is like this Dutch word called *gezellik*, which signifies comfort. The whole ethos is about a physical and visual connection that comes, first, from a sense of coming home. There I am at home. As strange as it might seem, I'm comfortable in India. And because of that sense of comfort, one experiences a sense of artistic license, of deeper fundamental freedom and support. There's a sense in which India says, "Here it is: take what you need. It's O. K." Everyone says this, I'm sure, but I had amazing experiences with people in India. They

At the Sanskriti Museum with O. P. Jain, Vishal Gujral, and prime minister V. P. Singh

Lee Waisler's physical connection to India started with an introduction to Vishal Gujral by Beatrice Wood; later, when I. K. Gujral became the prime minister of India, he invited Waisler to India. Pictured here, from left to right in the foreground, are O. P. Jain, Lee Waisler, Vishal Gujral, and prime minister V. P. Singh.

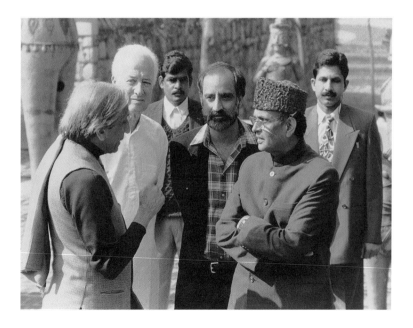

made me aware of capabilities I had as a human being, and as a result of that as an artist, that I had no consciousness of whatsoever.

GP: *Are you referring to artists chiefly in terms of people who made you aware of your capabilities?*

LW: Some were artists, but not all. One day I was in a village, right outside of Delhi, and there was a man leaning against a building. Somehow this man, with great deliberation, caught my eye and I looked at him. He was wearing an orange, very porous robe, and there were two apples on the ground in front of him. And he looked at me, and I looked at him, and I don't know what happened but in a very short time I was weeping, absolutely weeping, and no conversation had transpired, of course. He then released me, visually and physically, just like you'd shake water from your hair, and I started to compose myself and then he handed me one of his apples.

Lee Waisler with
Keshav Malik,
New Delhi, 1998

GP: *What do you make of this experience?*

LW: I can only tell you that the next day I called up Keshav Malik and told him I had a painting for him to see. I didn't ever do that, since I was far from his house, but I had this painting of death which was in earth black, and that's what this experience was about. This was about my death and being told that it was going to be fine. That's all I can say; I have a great deal of feelings about it, but it's all I can say. It was an incredible experience.

But it was not unlike many experiences that I had there. It's like this sense of going to a performance of music and dance and just feeling like I was connected to these people—like there's this wonderful sense of humanity and

they're part of you. In India, there's a certain respect when they know you're an artist that is not like anything that exists in the Western world.

GP: *I hear that you keep spiritual company with Paul Celan and Primo Levi.*

LW: I did a series of etchings and they're based on Primo Levi's words. Primo Levi is about the importance of silence and how, in spite of everything, to maintain a dignified silence is to maintain one's humanity. Paul Celan is about, for me, a kind of material, sacred monument of stone, of ash, of things that are in the shadow—and that feeds perfectly into my work. Both of these men are suicides, and I don't know what consequence that has for me, but there's something there as well.

GP: *If you were to characterize your own artistic periods, how would you describe them?*

LW: First, there were largely graphic images. Then, in the painting, I became aware of the unity of micro- and macro-matter by just seeing spots of paint on my studio floor. I had this epiphany at twenty-five—which is an age, of course, when you can just feel very connected—and I did a lot of stellar, ethereal paintings based upon that. Then I started painting a kind of monumental painting based on the human figure in connection with very minimal, abstract architectural elements. Eventually, wood came into the work. Then the materials, for their symbolic importance, came in and that really has continued through to the present, including the use of silicone carbonate. Without carbon, there's no life on earth, and I've found this amazing steel black material which I was able to incorporate into my work.

GP: *What direction do you see your work taking in the next few years?*

LW: I can't answer that because I don't know. Mandalas have interested me,

and I noticed that the most recent ones are no longer symmetrical—the circles are no longer complete; there are openings, and the circles are broken. The first ones were only paint, and now wood is coming back, as well as silicone carbon and sand.

GP: *Your art is in the permanent collections of museums like the Met, the V&A, the Jewish Museum, and the Smithsonian Institution, to mention only a few. How would you like to be remembered as an artist, and what artistic impact do you believe you've made?*

LW: In personal terms, I'd like to be remembered as someone who *worked* until he died. In historical terms, I'd like to be seen as one of those artists who have found a way to live through the twentieth century and maintained his humanity to be able to say, "There go I."

GP: *Arturo Schwarz has described your work as "roughly elegant, heartrendingly pure, and having balanced harmony." What adjectives would you use?*

LW: The best ones are the most autobiographical. They're most like myself; they show the confusion and the resolution that I see in myself, and they show the challenge and the impossibility of it all.

GP: *You've said that forty years ago, throwing paint was an act of liberation. What would be an act of liberation today?*

LW: Intuiting and expressing that intuition which pertains to limits, which pertains to containment. What I've come to believe is that there's a greater sense of force that can be issued from compression rather than expansion. Without imploding—and it's a very delicate forcefield—it's the sense of compression, I believe, that relates to our sense of hope and to that which is anti-chaotic.

GP: *What is the least recognized influence upon your work?*

LW: The least known influence upon my work is my maternal grandfather, who was an inventor and a dreamer—because that man, against the backdrop of my rather stern, silent, and powerful father, said and demonstrated, "You may cry during a Puccini aria," which he did invariably. I don't know that I've been able to communicate this in my work. That man at the Rider Gallery said to me, "You come in with a meat cleaver," and that was my father. Now, I'd like to have them say, "You come in with a feather, but what enormous power it has." That's what I'm striving for. And that's India.

Daniel Ellsberg with Lee Waisler at the Nuclear Test Site in Nevada, 1982

GP: *What compels you in the art world today?*

LW: I think the possibilities of the art world, and the greater world, are extraordinary because of the sheer variety of what's being produced. It's being produced with such apparent spontaneity, and there's a sense of this cauldron of chaotic energy that I think is constructive, and I believe that something extraordinary will issue from that.

I'm not frightened by a lack of direction, like a lot of people are, because I personally have a direction and I feel confident and hope that some people will continue to recognize it—but, anyway, that's history.

GP: *What question would you ask yourself if you had been the interviewer?*

LW: What makes you continue?

GP: *And what does?*

LW: The last painting I did.

Catalog

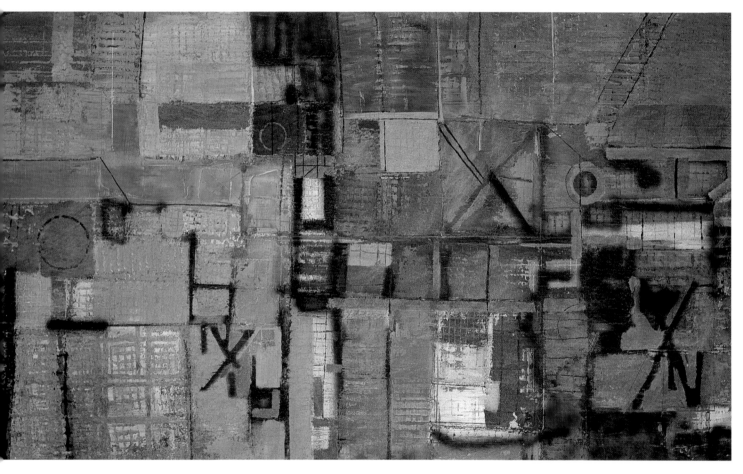

TARGET CITY

84" x 144"; Acrylic, glass, and sand on canvas; 1970

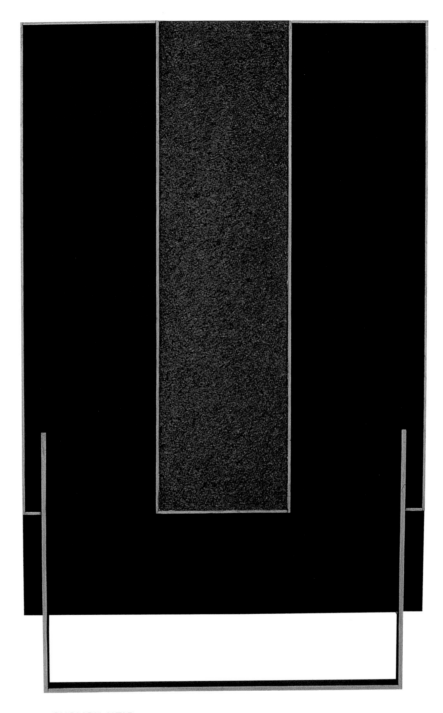

GNOMON-ALTAR

54" x 60"; Acrylic, glass, sand, and wood on canvas; The Vera Silvia and Arturo
Schwarz Collection of Contemporary Art at Tel Aviv Museum, Israel,1984

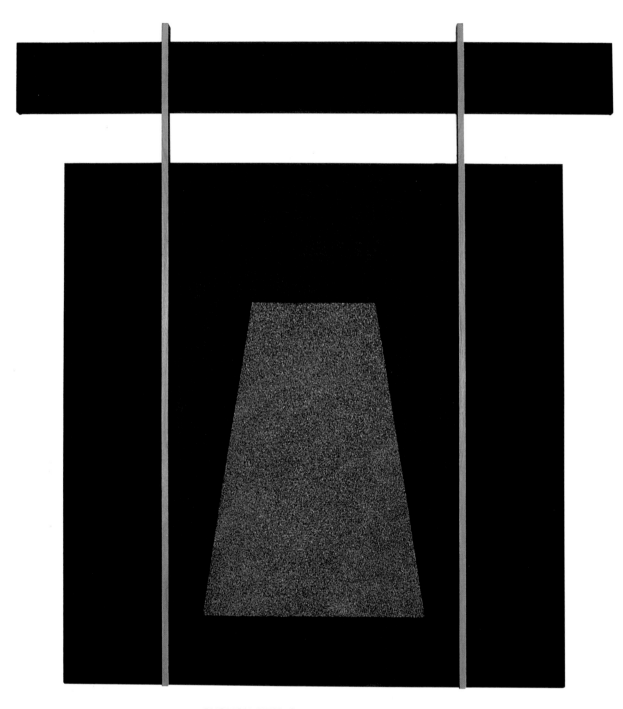

GNOMON ALTAR G

82" x 72"; Acrylic, stone, and wood on canvas; 1982

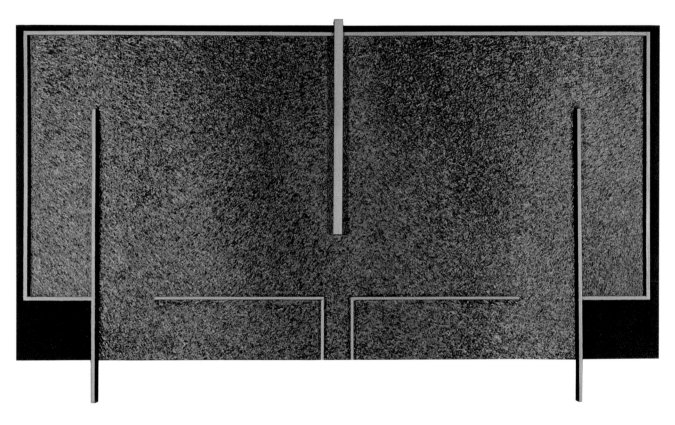

NILE ALTAR

55" x 96"; Acrylic aggregate wood on canvas; 1982
Published in *Lee Waisler: Mostra Retrospecttiva*
1968–1988 by the Comune Di Ferrara, page 28

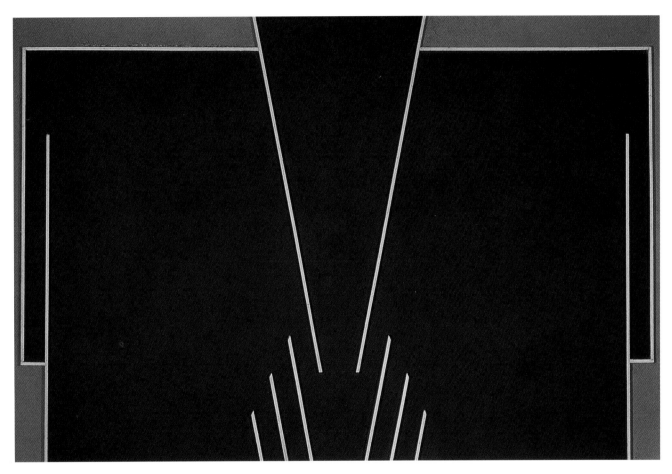

GNOMON R

70" x 108"; Acrylic wood on canvas; 1985

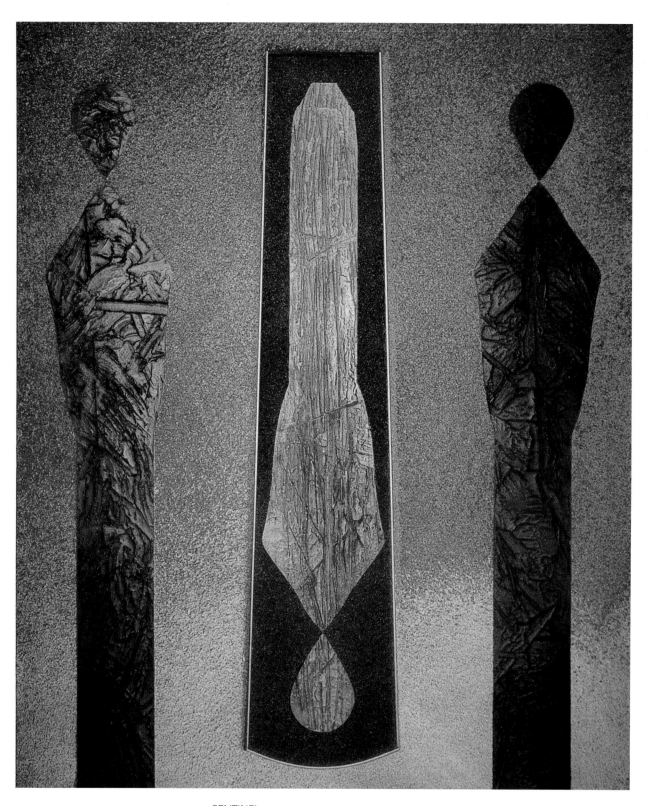

SENTINEL

80" x 66"; Acrylic, glass, sand, and wood on canvas

Scott Robinson Collection; 1986

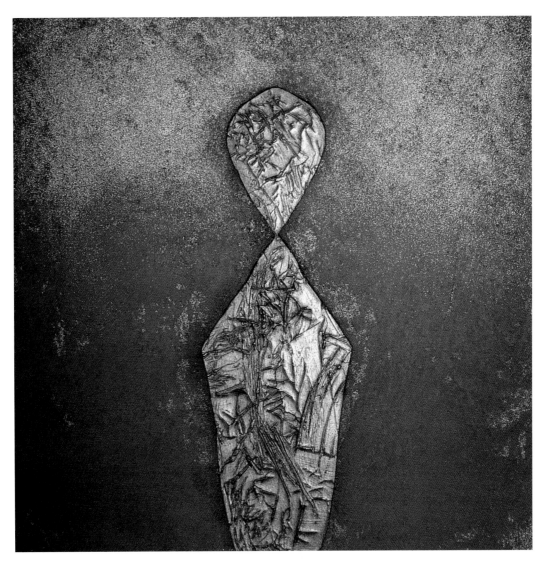

HOMAGE TO ALBERTO

48" x 48"; Acrylic, glass, and sand on canvas; 1987

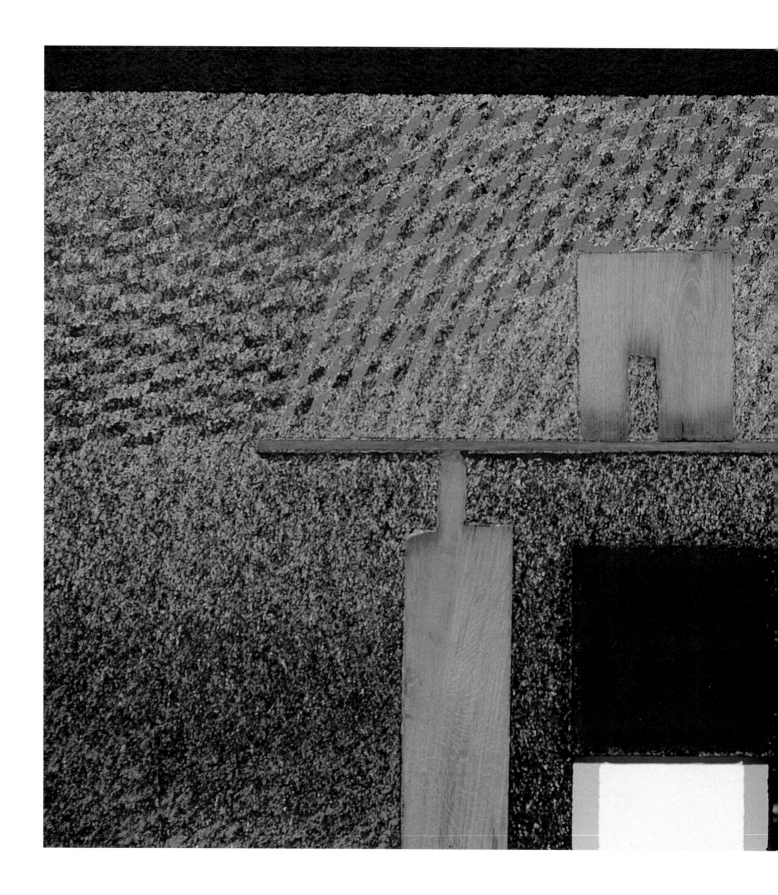

WHAT IS TO BE REMEMBERED

48″ x 78″; Acrylic, glass, sand, and wood on canvas;
1987
Published in *Lee Waisler: Mostra Retrospecttiva
1968–1988 by the Comune Di Ferrara*
In the collection of Galleria Civica D'Arte Moderna,
Ferrara, Italy

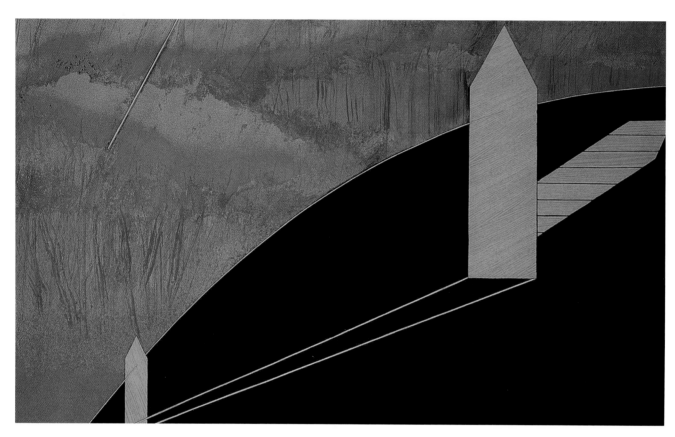

BLACKBRIDGE

54" x 90"; Acrylic, glass, sand, and wood on canvas; 1989

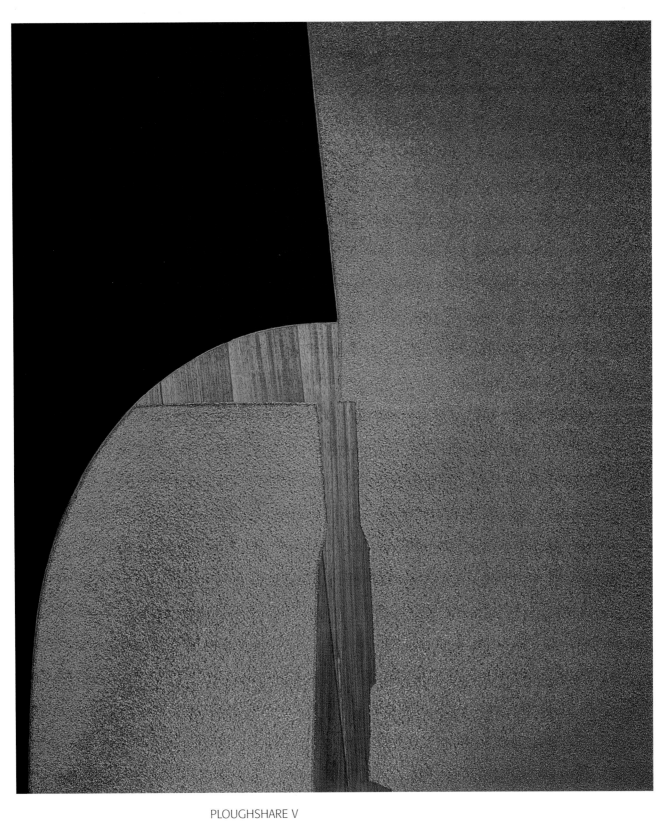

PLOUGHSHARE V

65" x 56"; Acrylic, glass, sand, and wood on canvas; 1989

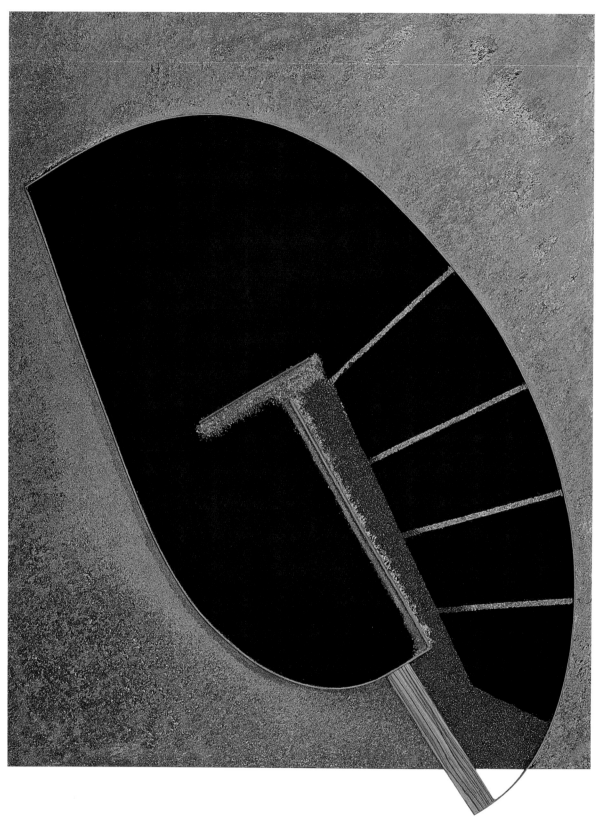

THE SLEEPING KING

64" x 84"; Acrylic, glass, sand, silicone carbonate, and wood on canvas; 1990

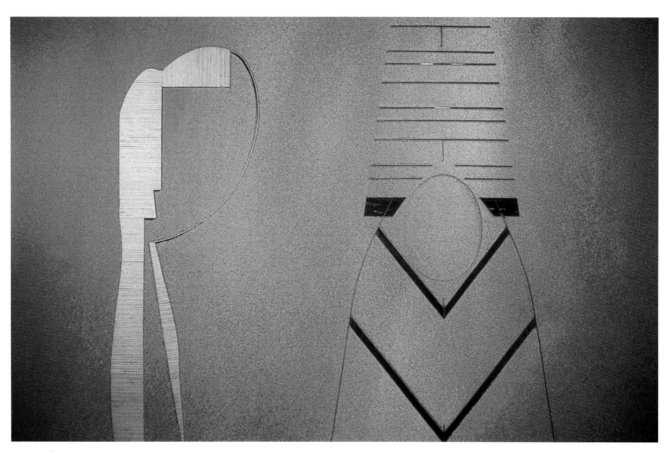

OEDIPUS AND THE SPHINX

67" x 108"; Acrylic, glass, sand, and wood on formed canvas; 1991

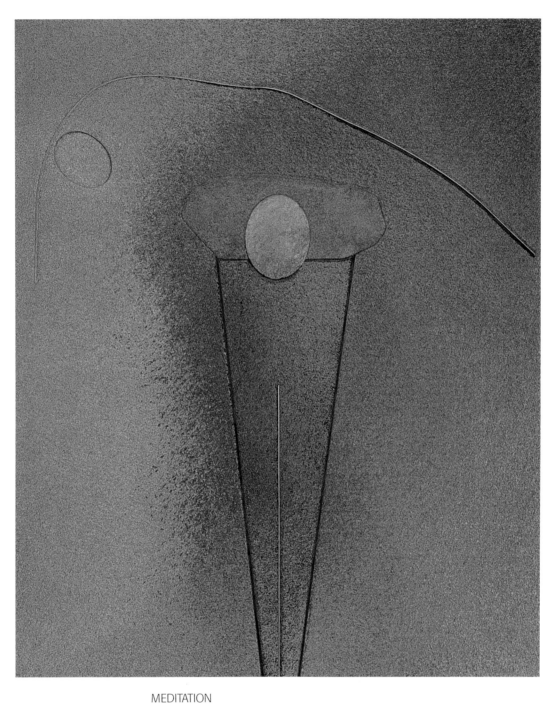

MEDITATION

80" x 66"; Acrylic, glass, sand, and wood on canvas; 1991

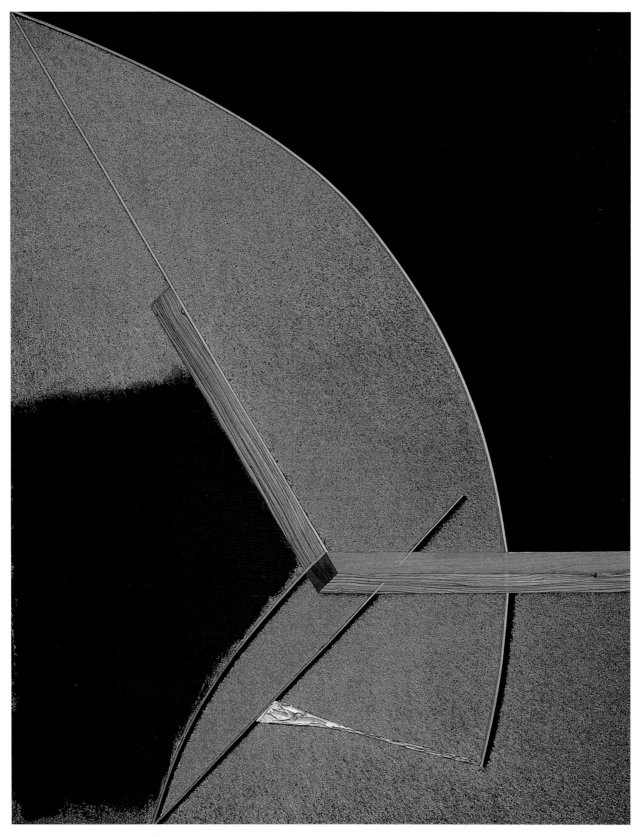

COUNTERPOINT

84" x 66"; Acrylic, sand, glass, and wood on canvas; 1992

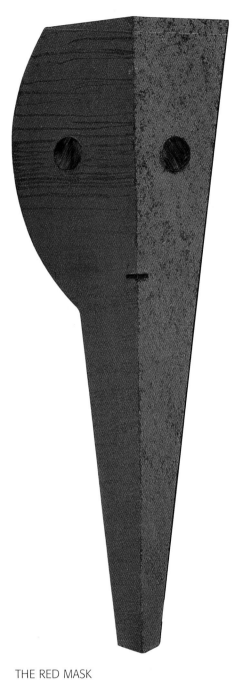

THE RED MASK

64" x 22 x 10"; Acrylic, glass, and wood on canvas; 1992

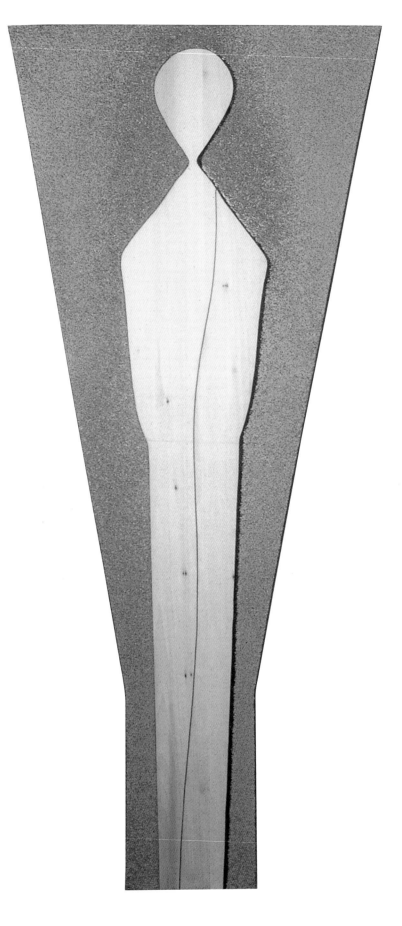

MAN

81" x 34"; Acrylic, glass, sand, and wood on shaped canvas; 1993

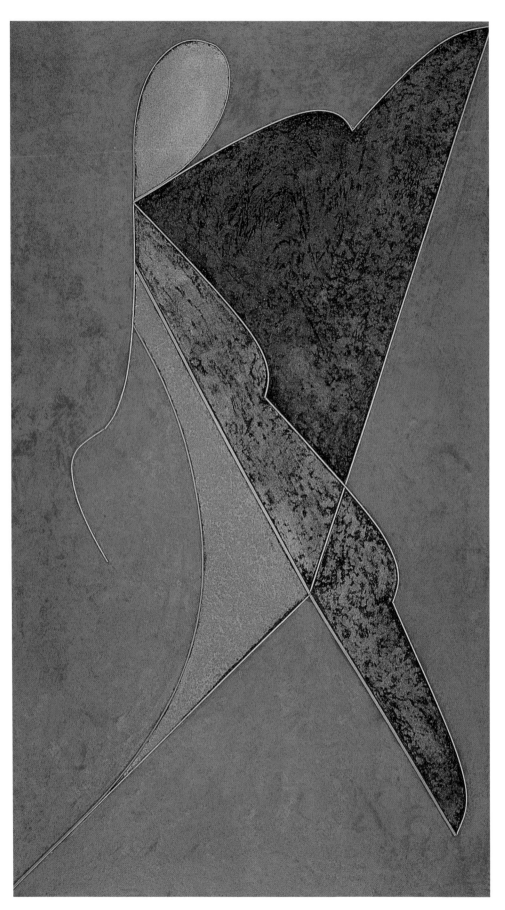

LUFTMENSCH

84" x 48"; Acrylic, glass, sand,
and wood on canvas; 1993

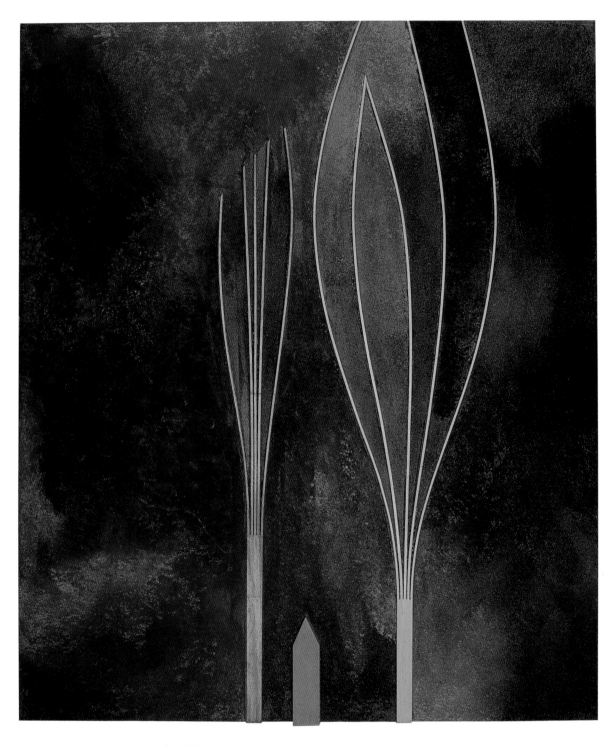

SHELTER

78" x 66"; Acrylic, glass, sand, copper, and wood on canvas; 1993

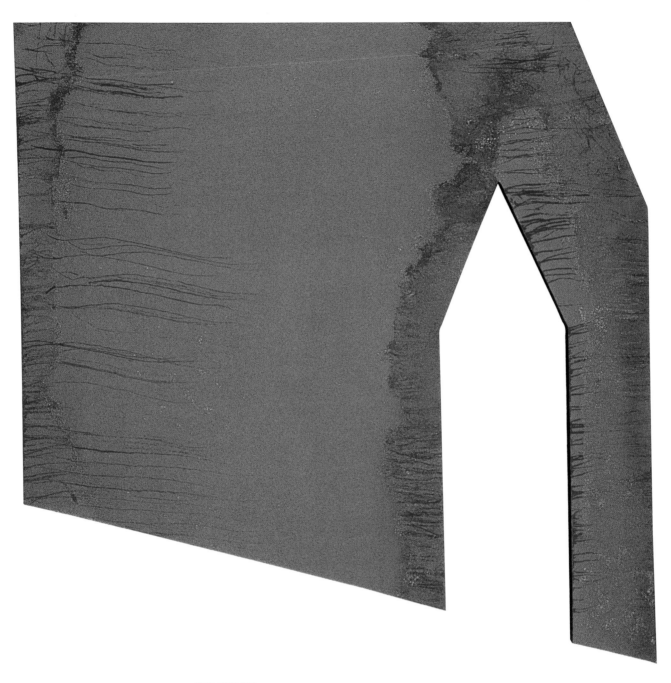

RED HOUSE

60" x 60"; Acrylic, glass, and walnut shell on shaped canvas; 1993

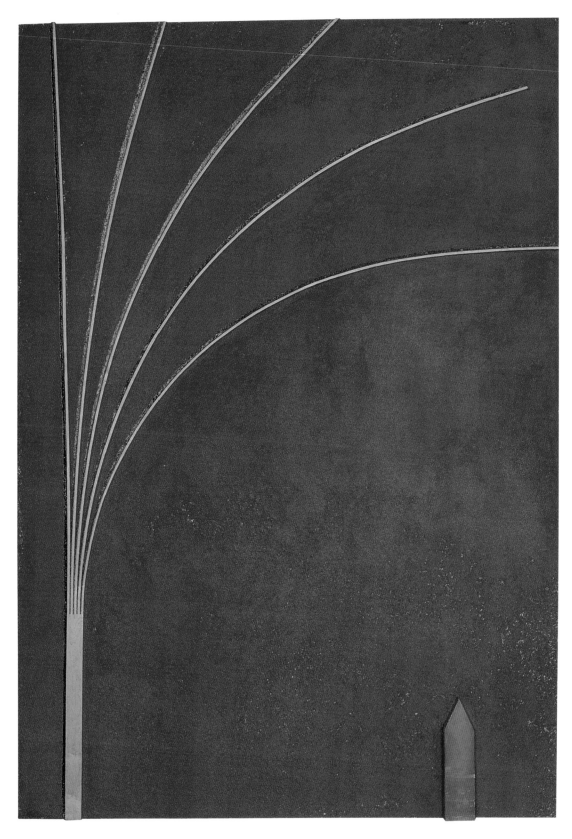

TREEHOUSE

80" x 56"; Acrylic, glass, sand, copper, and wood on canvas; 1993

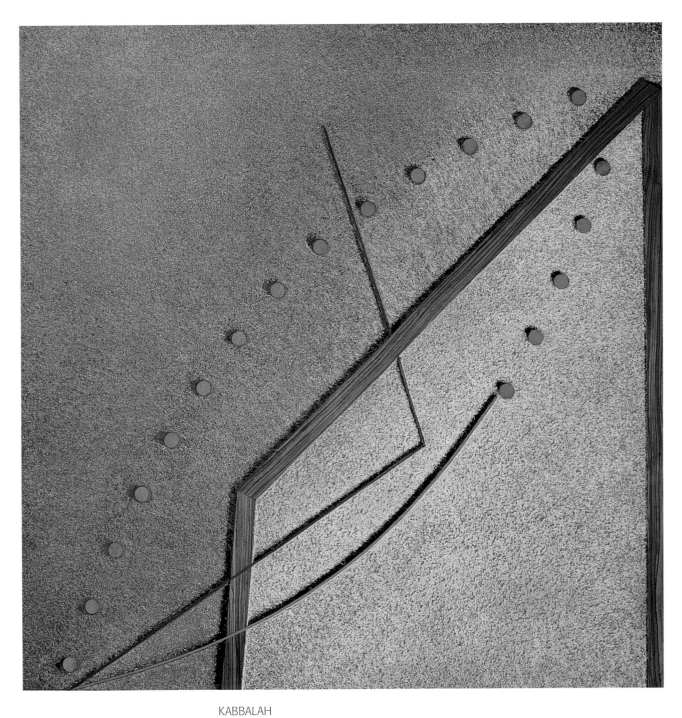

KABBALAH

66" x 66"; Acrylic, glass, sand, and wood on canvas; 1995

Tibet House Collection, New York

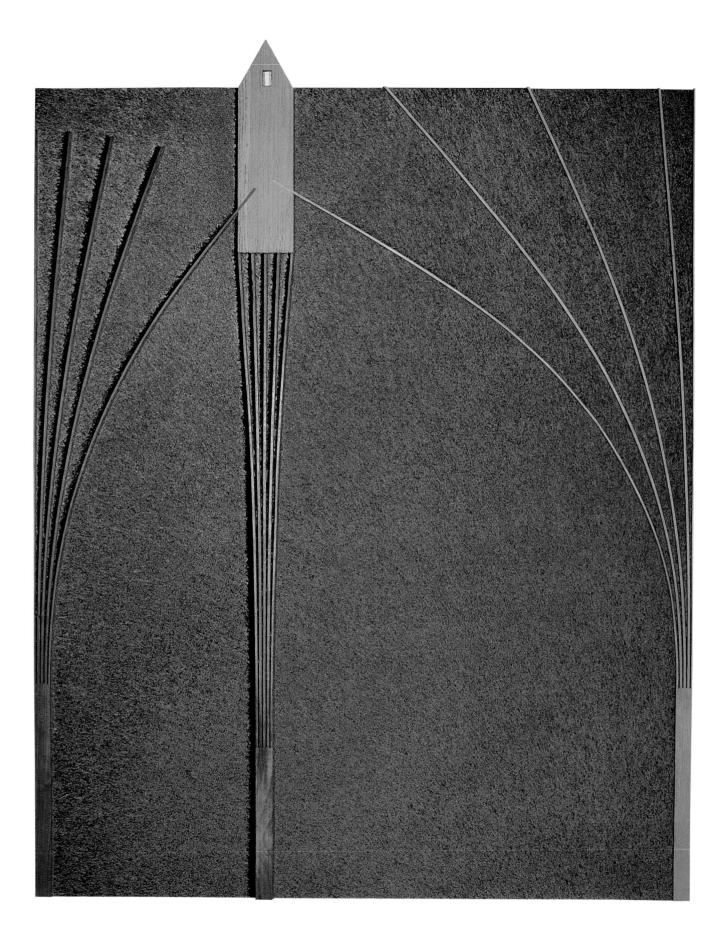

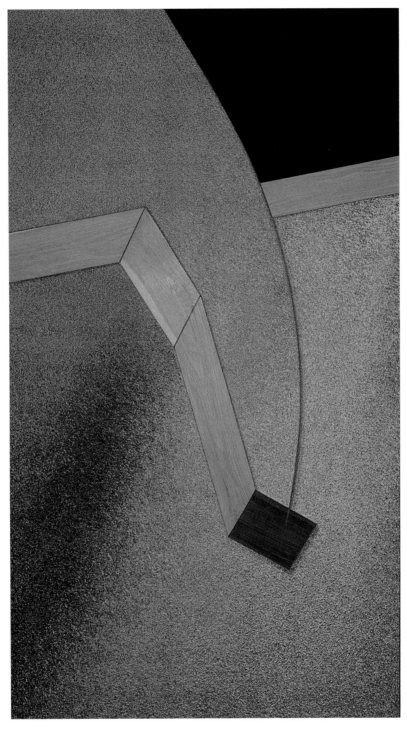

CONNECTION

84" x 47"; Acrylic, glass, sand, and wood on canvas; 1995

WATCH TOWER

83" x 66"; Acrylic, glass, sand, and wood on canvas; 1995

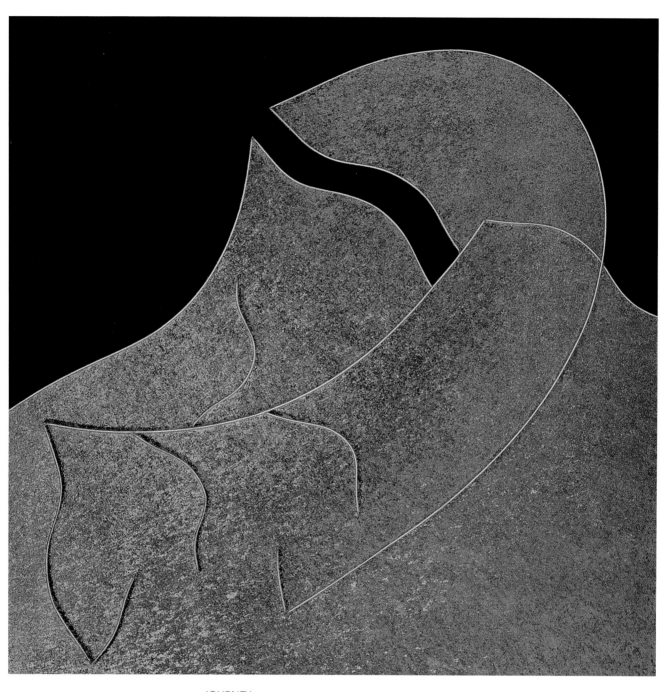

JOURNEY

66" x 66"; Acrylic, glass, sand, and wood on canvas; 1996

DUTCH WINDOW

72" x 72"; Acrylic, sand, glass, walnut shell, and wood on canvas; 1996

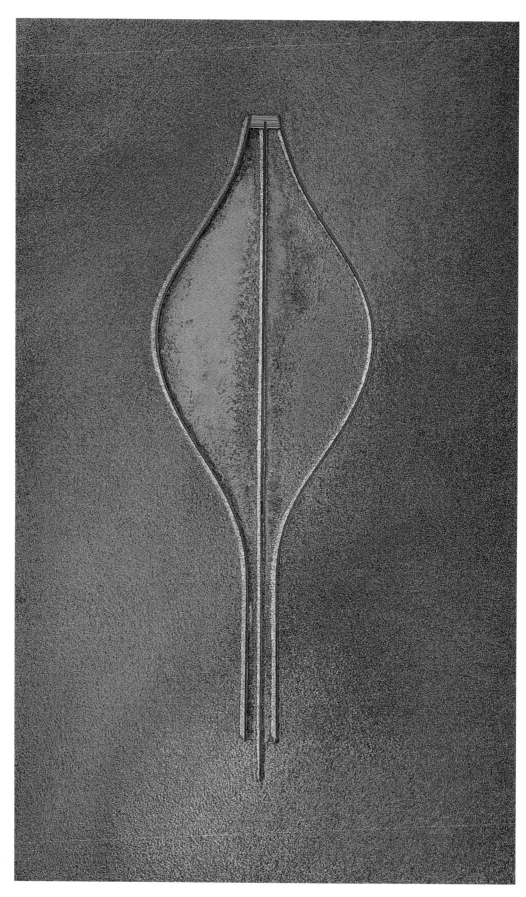

HARP

90" x 54"; Acrylic, glass,
sand, and wood on canvas;
1996

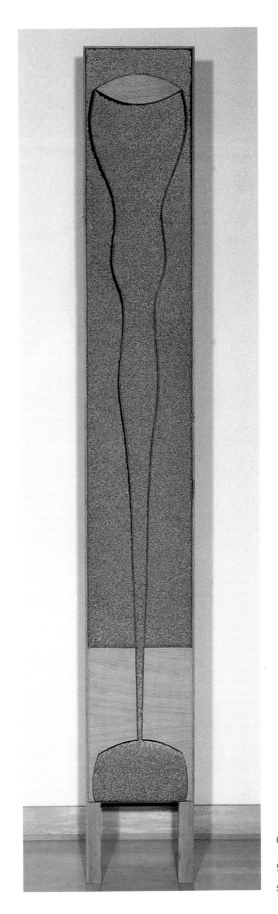

CONTAINER

94" x 13" x 3"; Painted sculpture, glass, sand, and wood; 1996

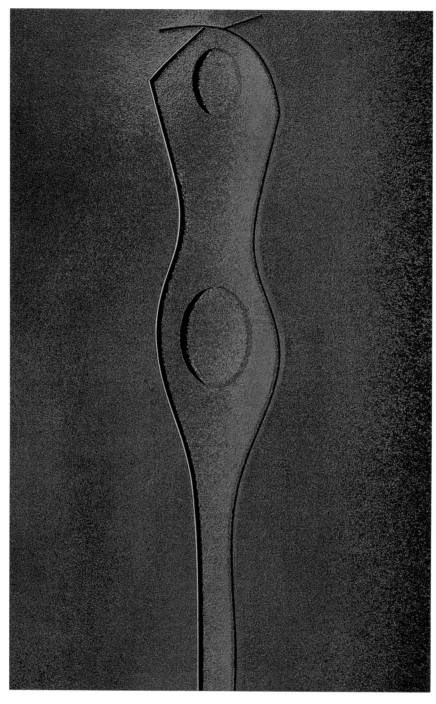

GODDESS

80" x 53"; Acrylic, glass, sand, and wood on canvas; 1997

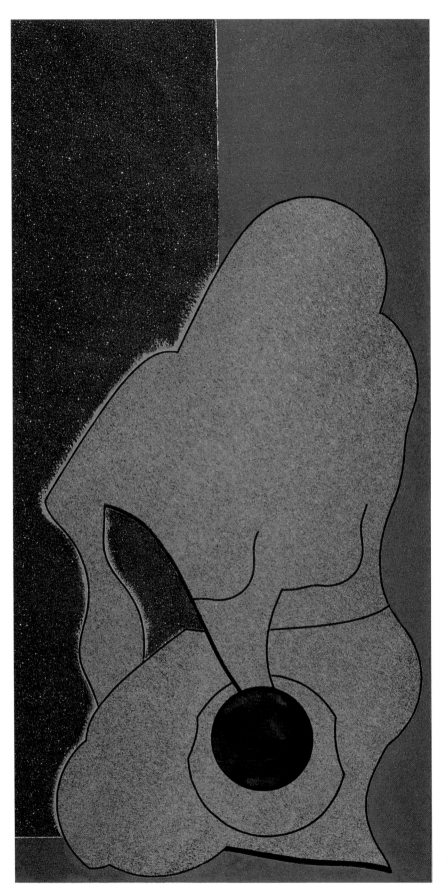

POTTER

96" x 48"; Acrylic, sand, stone, and wood
on canvas; 1997

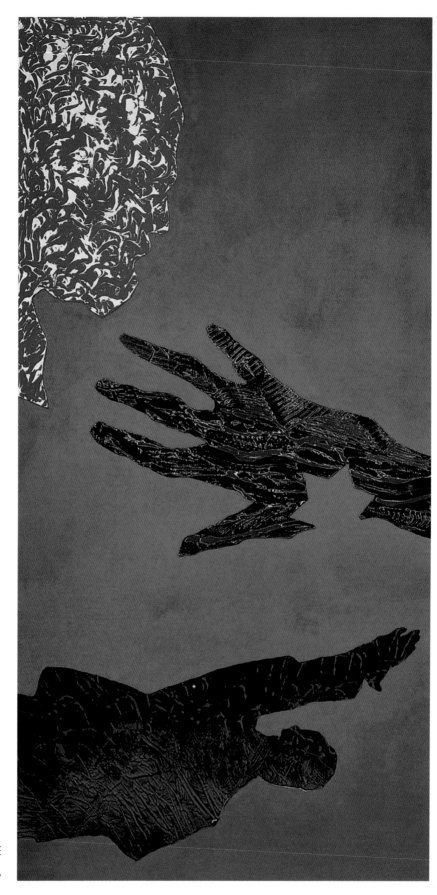

AN EYE FOR AN EYE

66" x 36"; Acrylic and sand on canvas; 1997

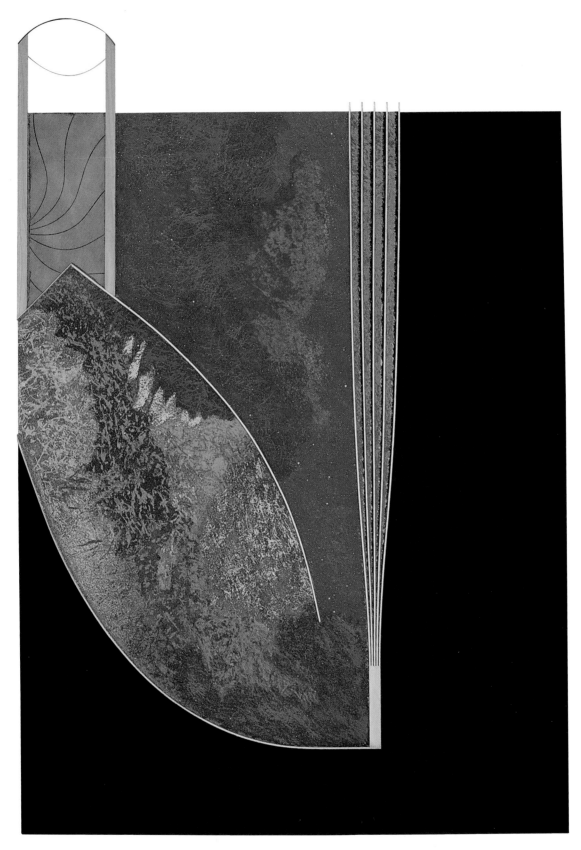

THE DAY WATCH

120" x 84"; Acrylic, sand, walnut shell, and wood on canvas; 1998

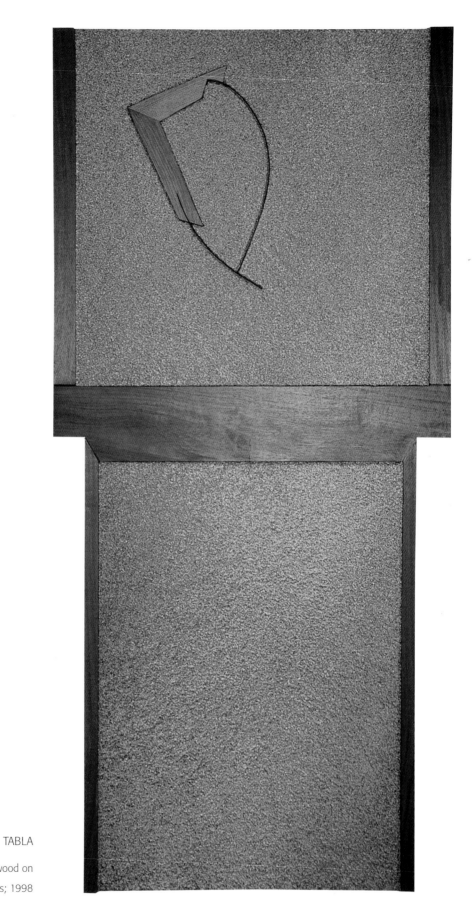

TABLA

76" x 36"; Acrylic, glass, sand, and wood on
shaped canvas; 1998

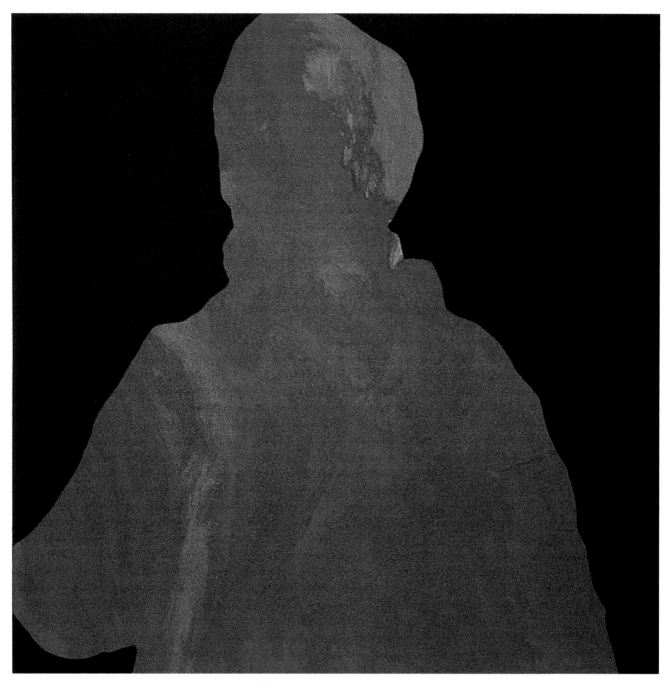

IMMIGRANT

36" x 36"; Acrylic, sand, and earth on canvas; 1998

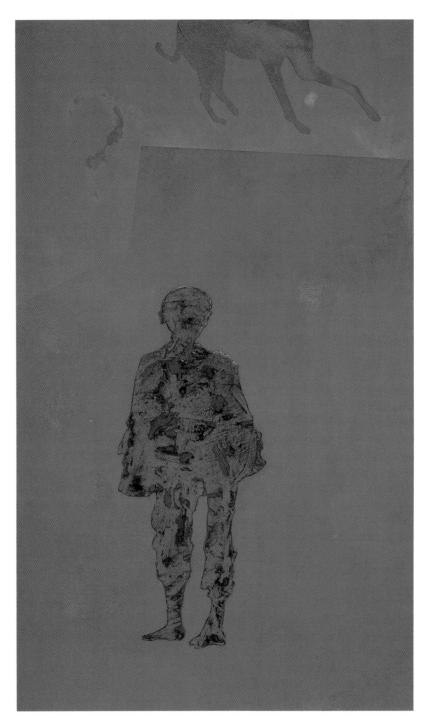

THE BOY

60" x 36"; Acrylic and sand on canvas; 1998
Fred and Beth Singer Collection

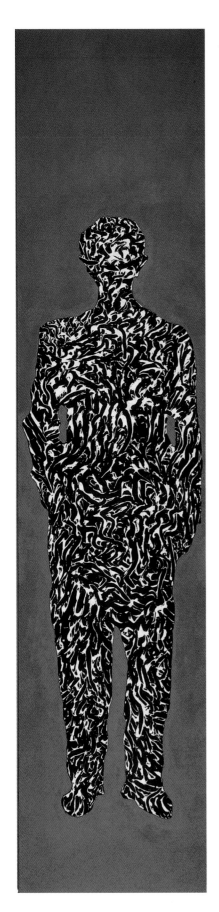

ARBETTER

96" x 22"; Acrylic on canvas; 1999

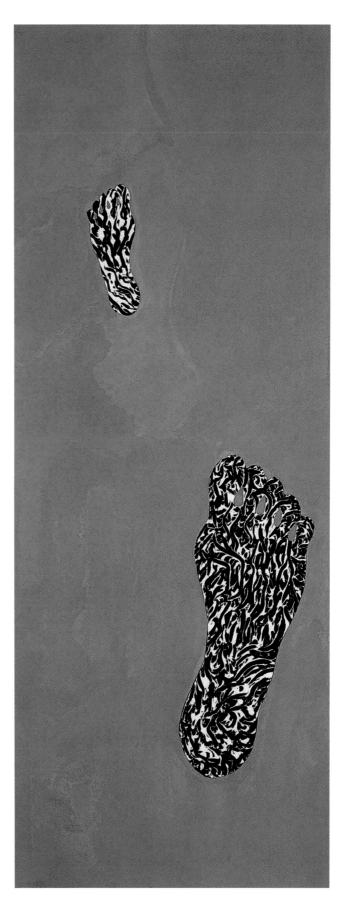

FOLLOWER

72" x 36"; Acrylic and sand

on canvas; 1999

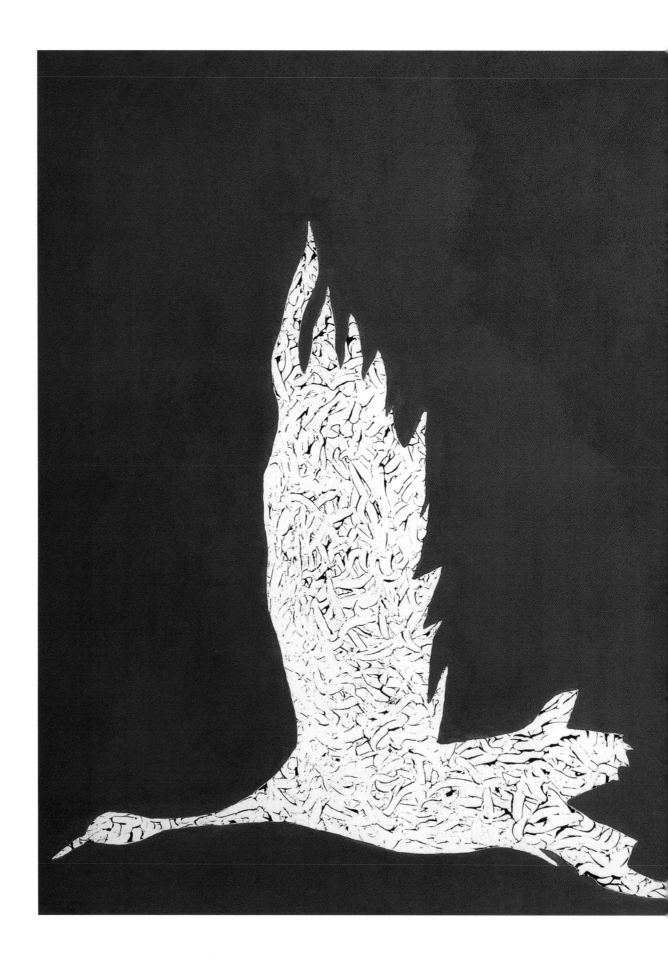

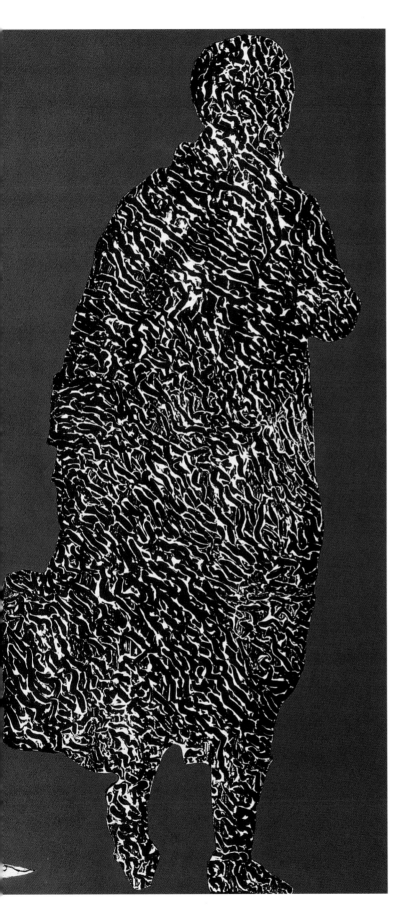

TRAVELERS

48" x 60"; Acrylic on canvas; 1998

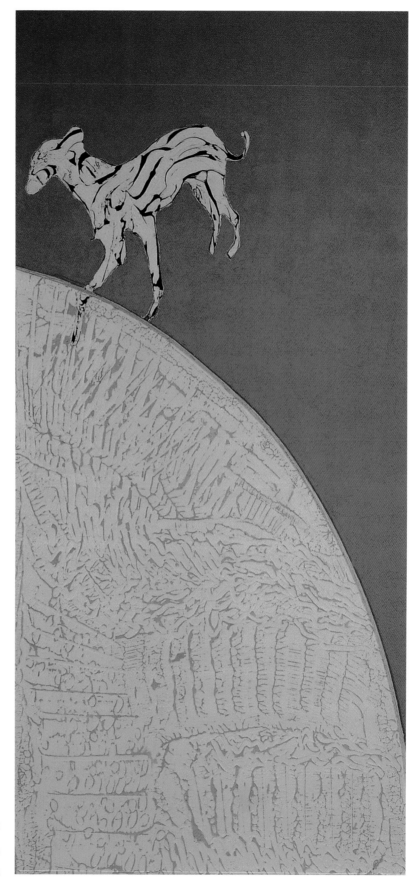

DELHI DOG

66" x 30"; Acrylic and wood on canvas; 1998

Published in *Art Forum,* February. 2000

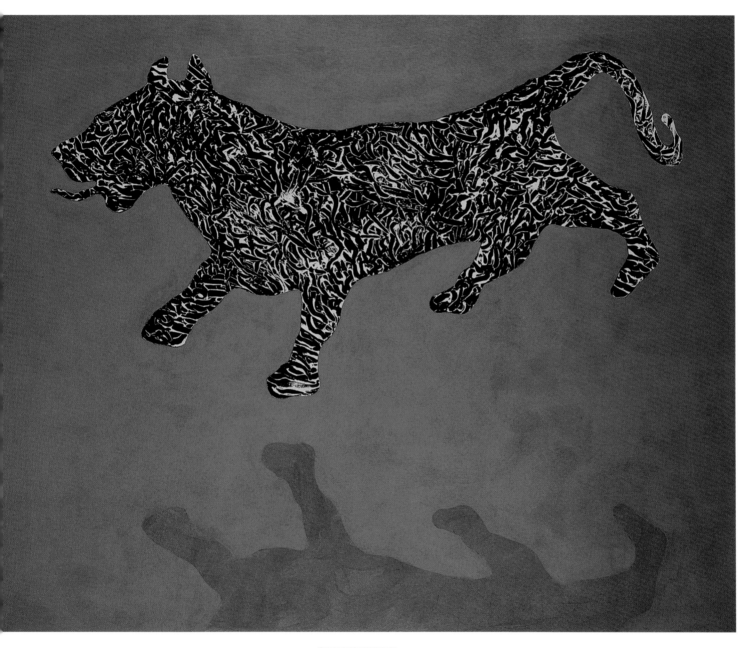

SHADOW TIGER

40" x 60"; Acrylic and sand on canvas; 1998

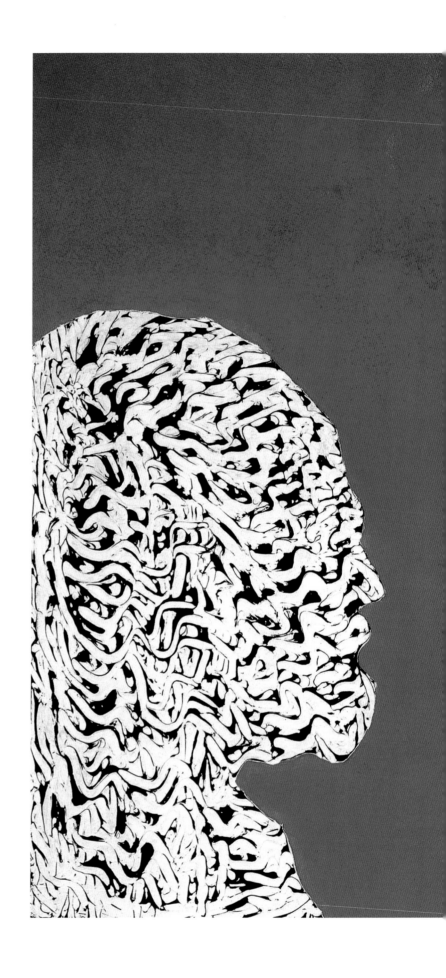

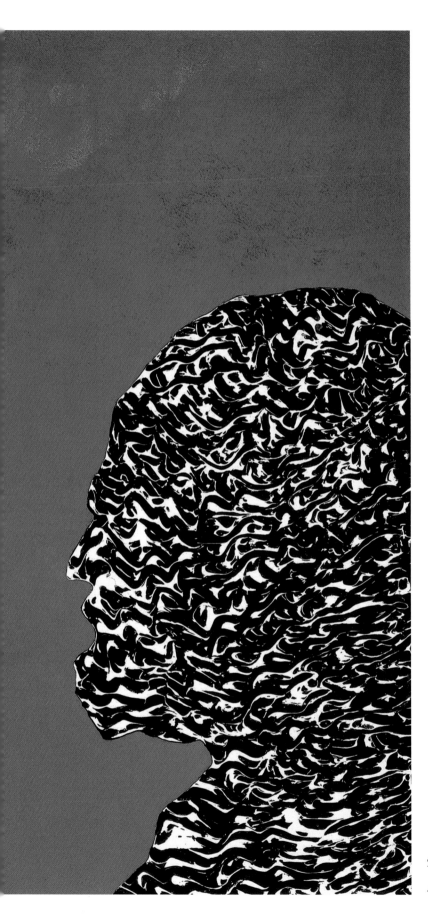

SIGMUND FREUD–SIGMUND FREUD

48" x 48"; Acrylic on canvas; 1999

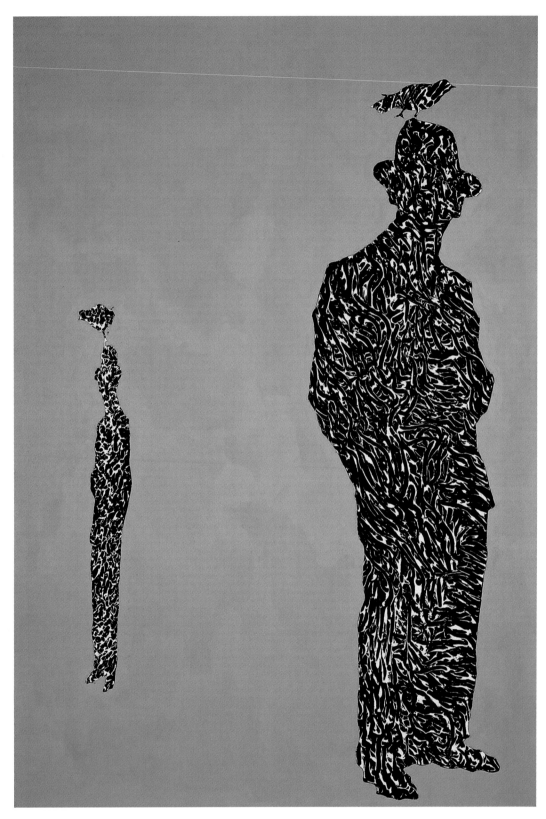

RETURN OF THE IMMIGRANT

78" x 54"; Acrylic, glass, sand, and wood on canvas; 1998

Fred and Beth Singer Collection

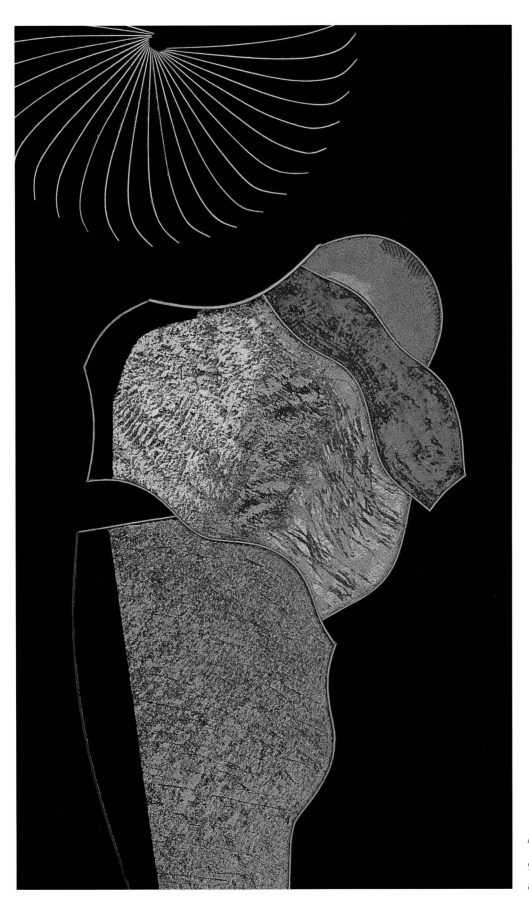

ABBA K

96" x 58"; Acrylic, glass, sand,
and wood on canvas; 1998

FUNNEL

48" x 60"; Acrylic, glass, sand, and wood
on canvas; 1998

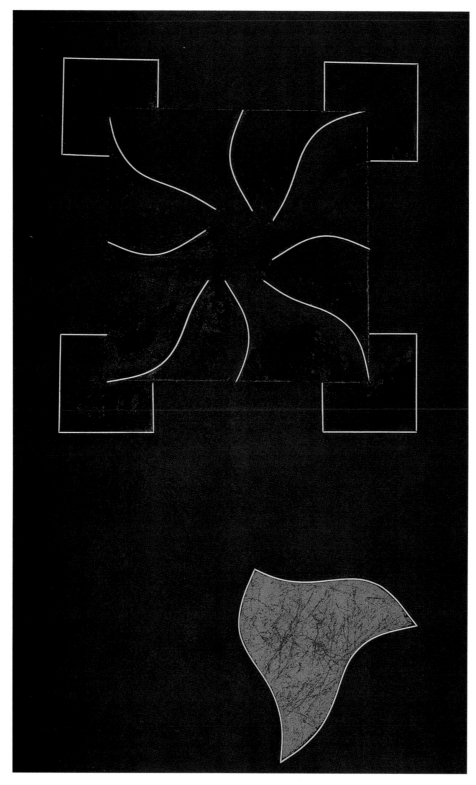

MANDALA MAKER

96" x 60"; Acrylic, silicone carbonate, and wood on canvas; 1999

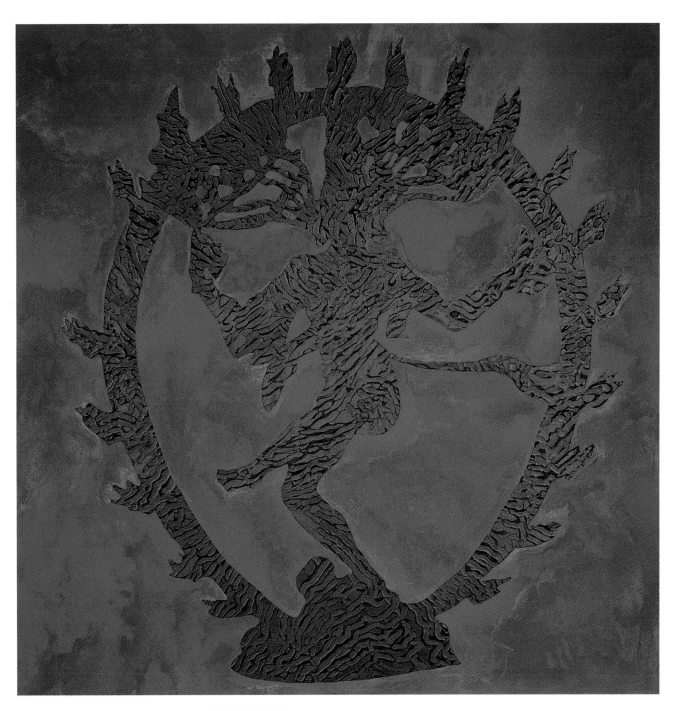

COSMIC DANCE II

48" x 48"; Acrylic and sand on canvas; 1998

Collection of Mr. and Mrs. Raman Kapur, Princeton, New Jersey

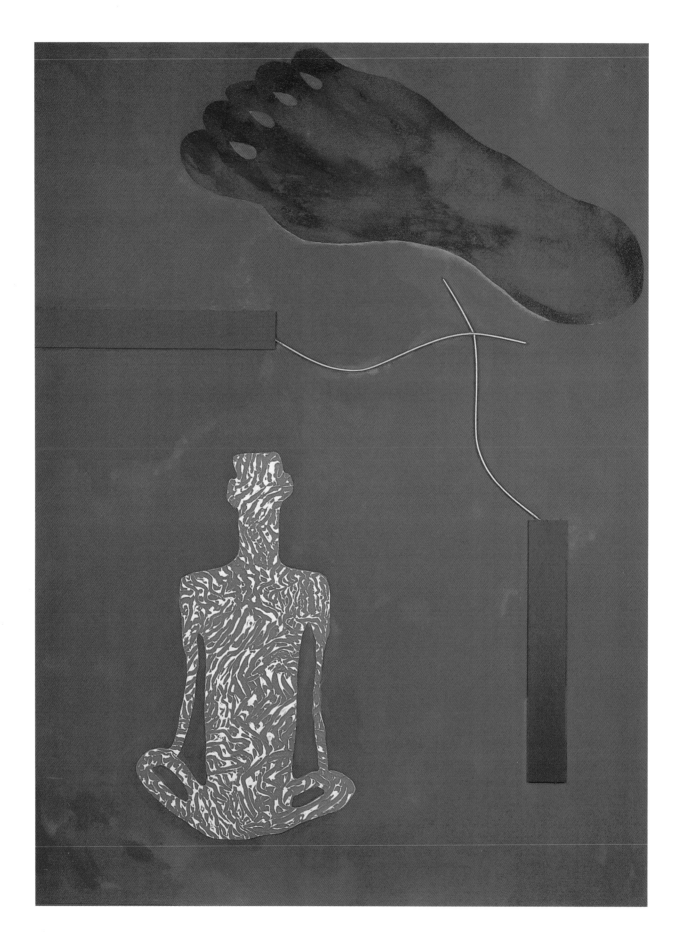

AVATAR

80" x 60"; Acrylic, wood, and silicone carbonate
on canvas; 1999

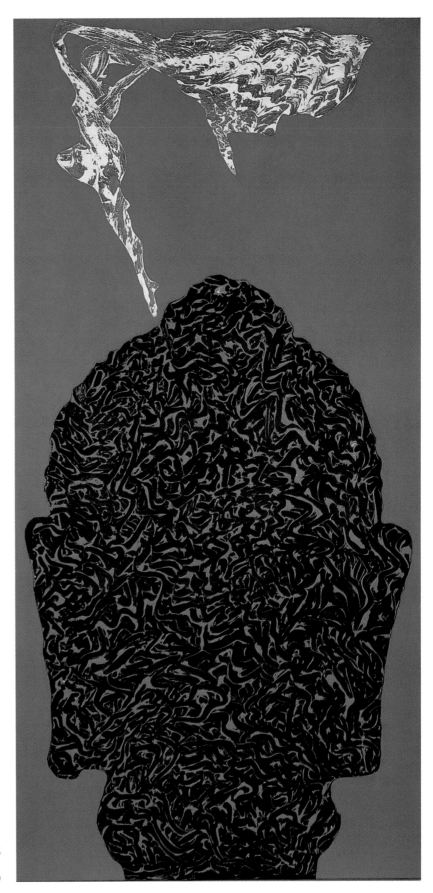

BUDDHA THOUGHTS

72" x 36"; Acrylic on canvas; 1999

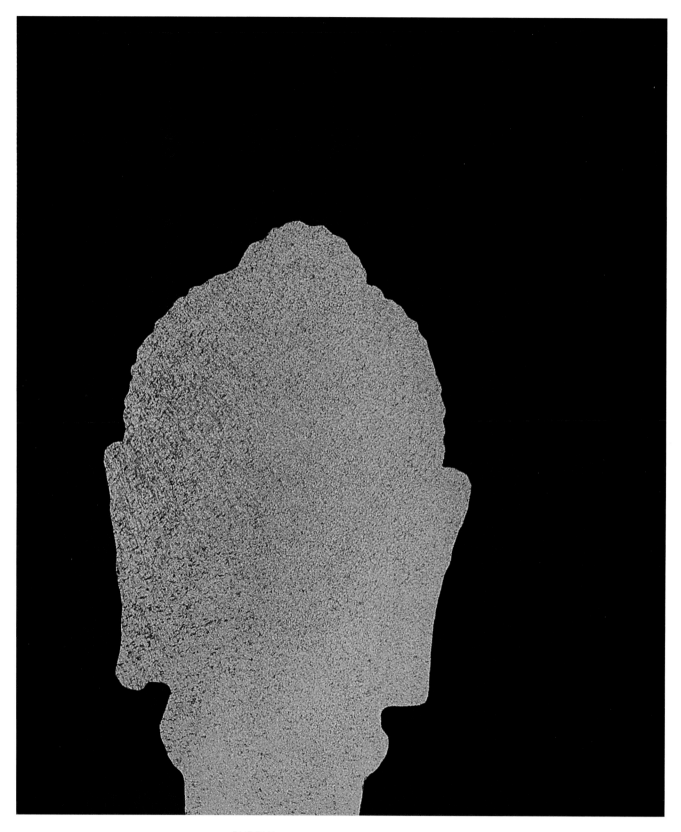

BUDDHA

72" x 60"; Acrylic, glass, and sand on canvas; 1999

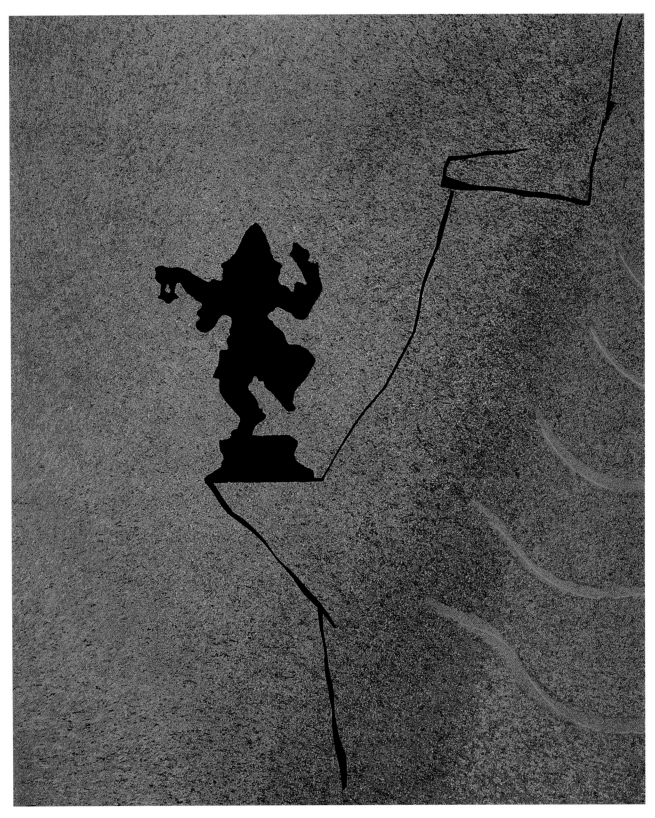

COSMIC DANCE

72" x 60"; Acrylic, glass, and sand on canvas; 1998

Michael and Scarlett Pildes Collection

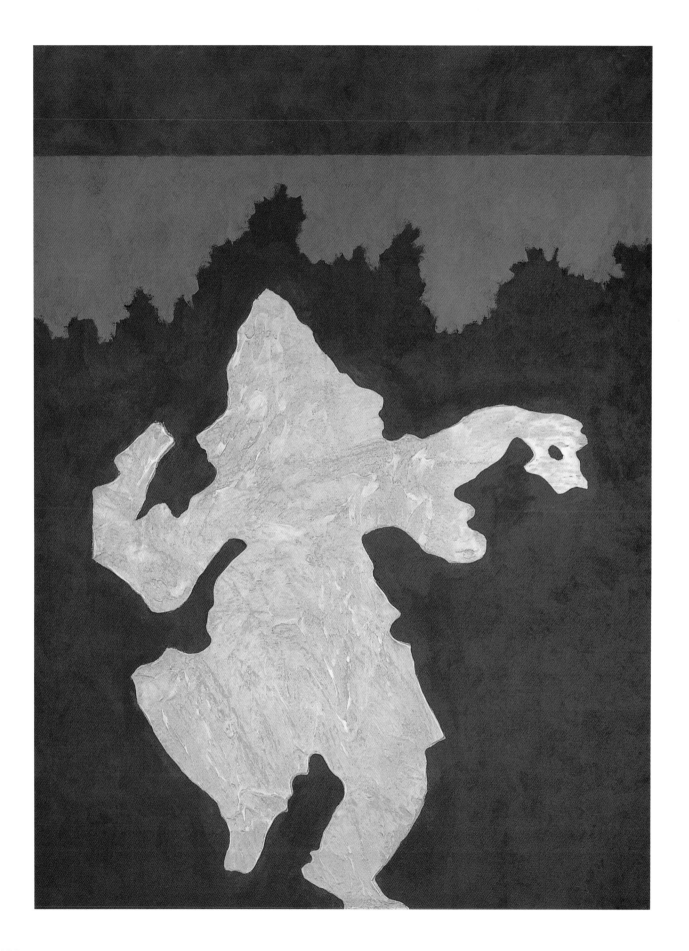

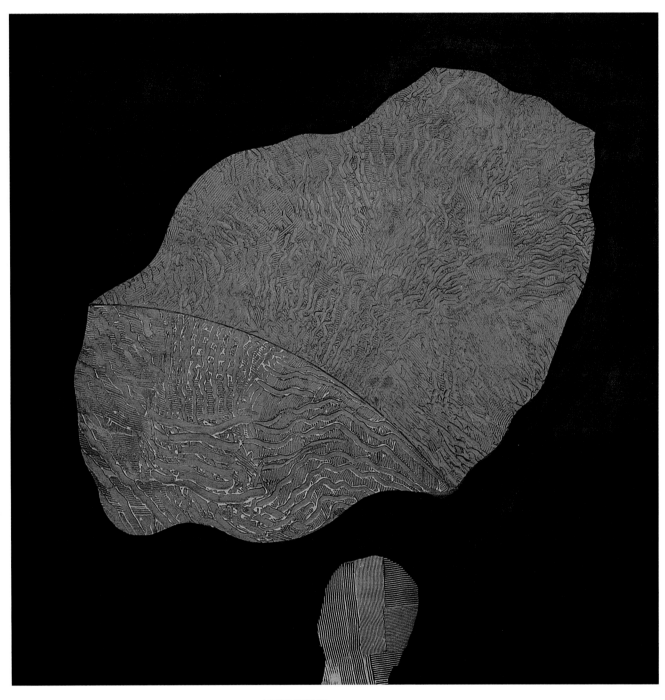

HEADSTONE

60" x 60"; Acrylic on canvas; 2000

DANCING GANESHA

48" x 36"; Acrylic on canvas; 1999

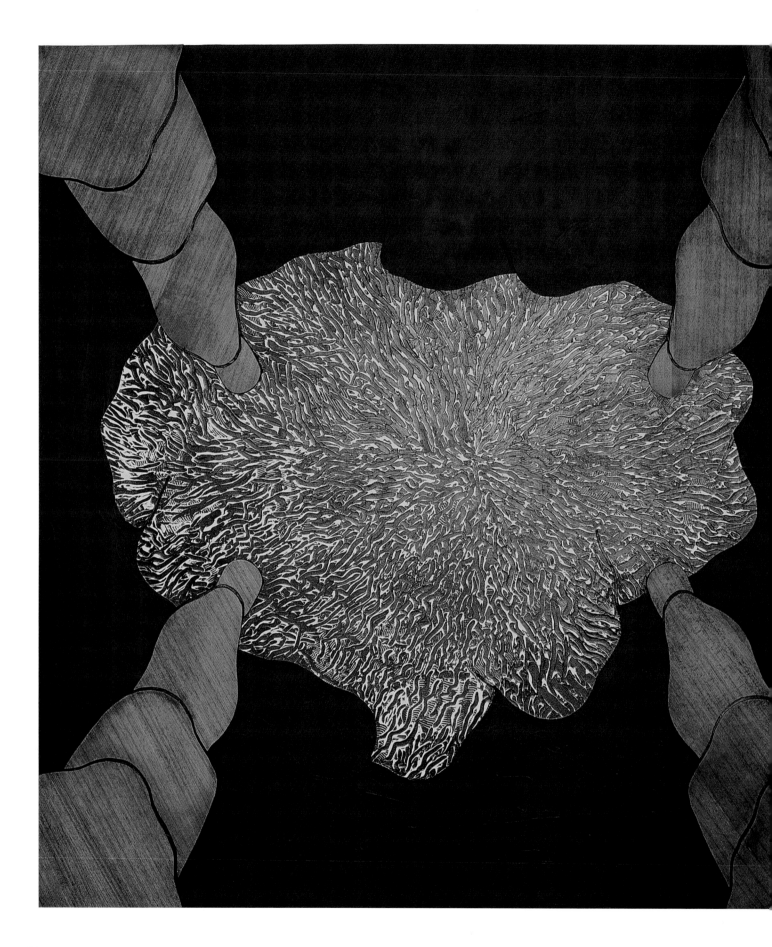

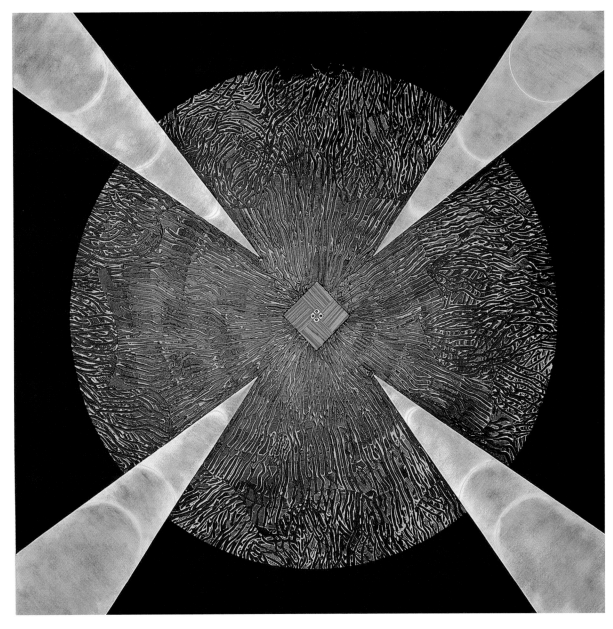

EARTHEYES

84" x 84"; Acrylic, wood, and porcelain on canvas; 2001

MARS TABLE

72" x 72"; Acrylic and wood on canvas; 2001

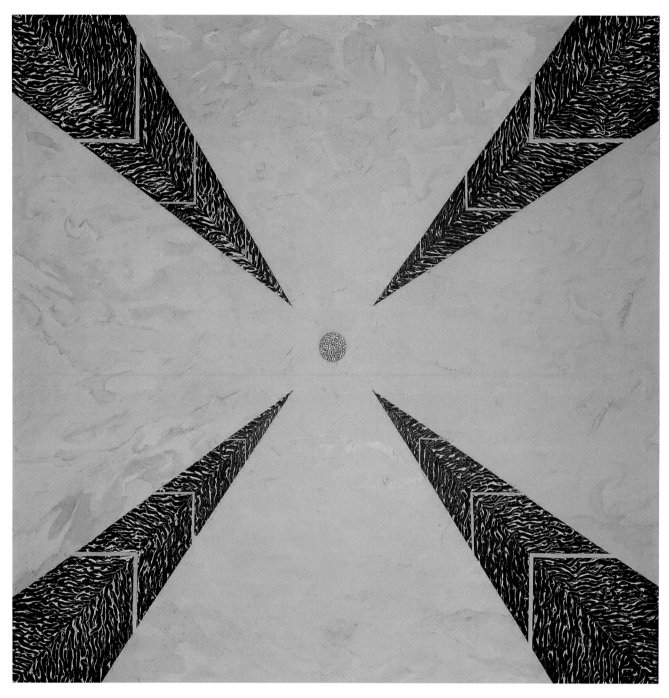

LOOKING BACK

90" x 90"; Acrylic and porcelain on canvas; 2001

THE PUZZLE

84" x 84"; Acrylic and wood on canvas; 2001

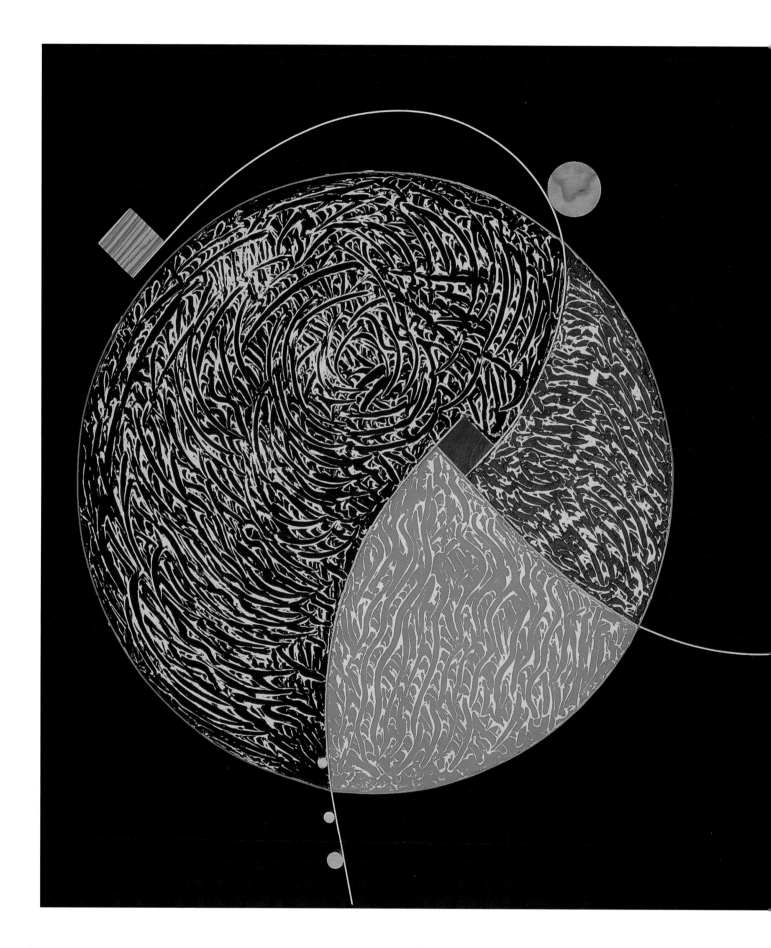

106

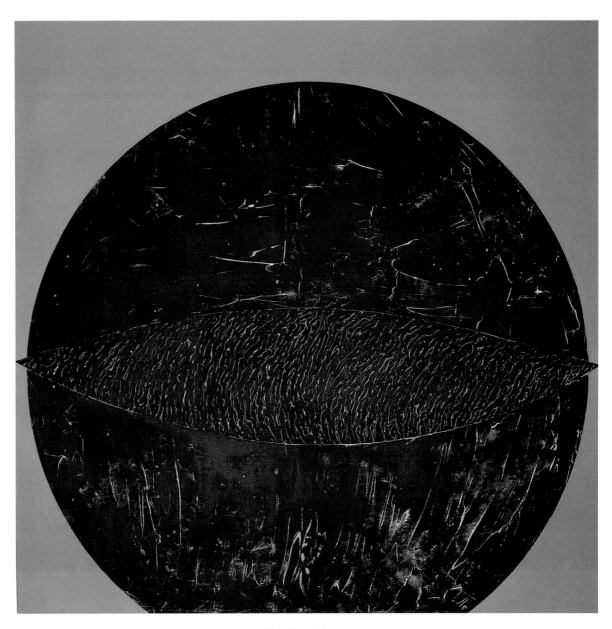

YELLOW MANDALA

72" x 72"; Acrylic on canvas; 2000

GALILEO

60" x 60"; Acrylic and wood on canvas; 2001

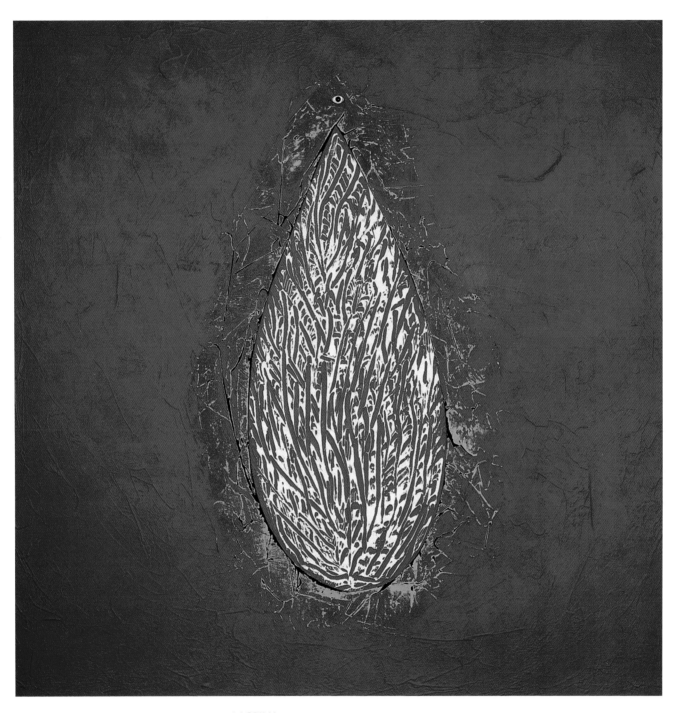

LAGRIMA

48" x 48"; Acrylic and porcelain on canvas; 2001

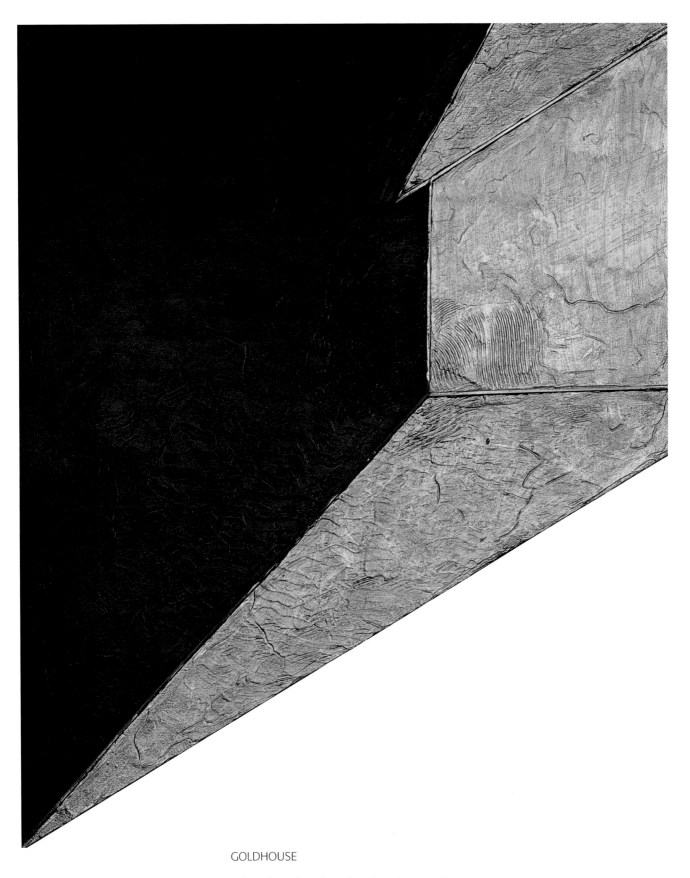

GOLDHOUSE

33" x 27"; Acrylic and wood on shaped canvas; 2001

DUOMO II

60" x 18"; Mixed media; 2001

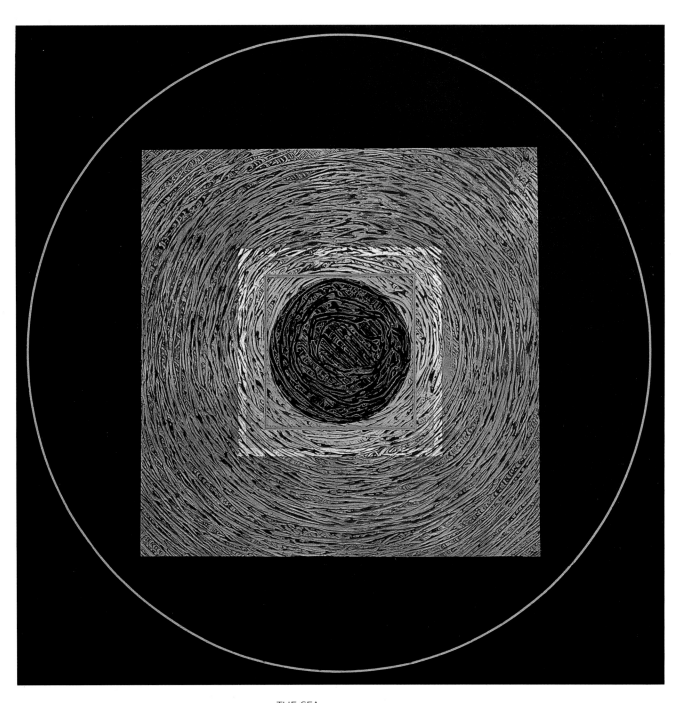

THE SEA

72″ x 72″; Mixed media; 2000

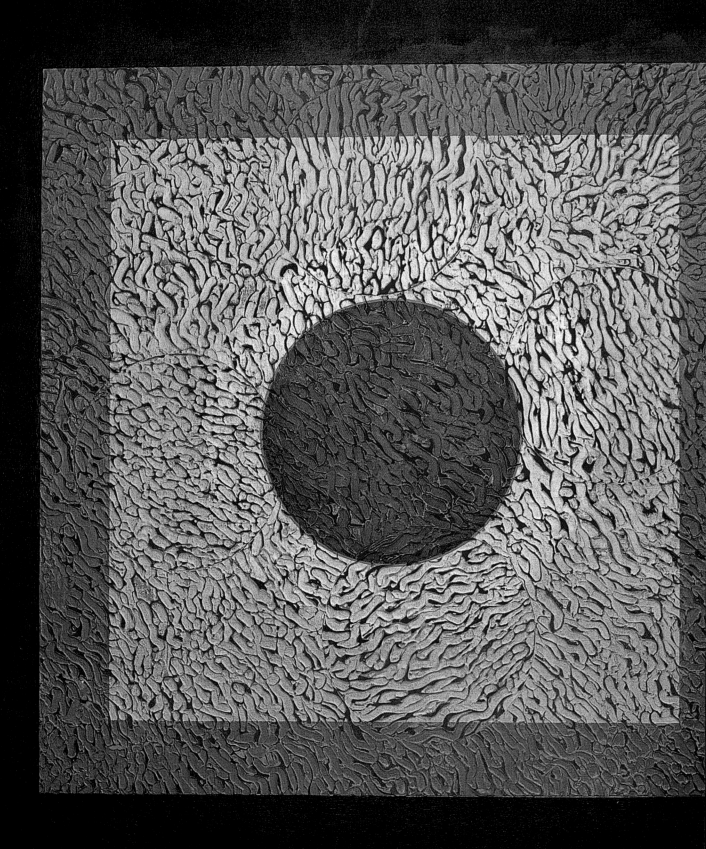

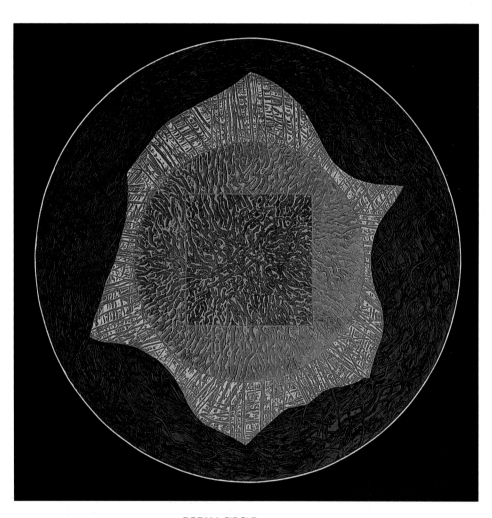

DREAM CIRCLE

60" x 60"; Mixed media; 2001

CIRCLE IN A SQUARE-G

60" x 60"; Mixed media; 2001

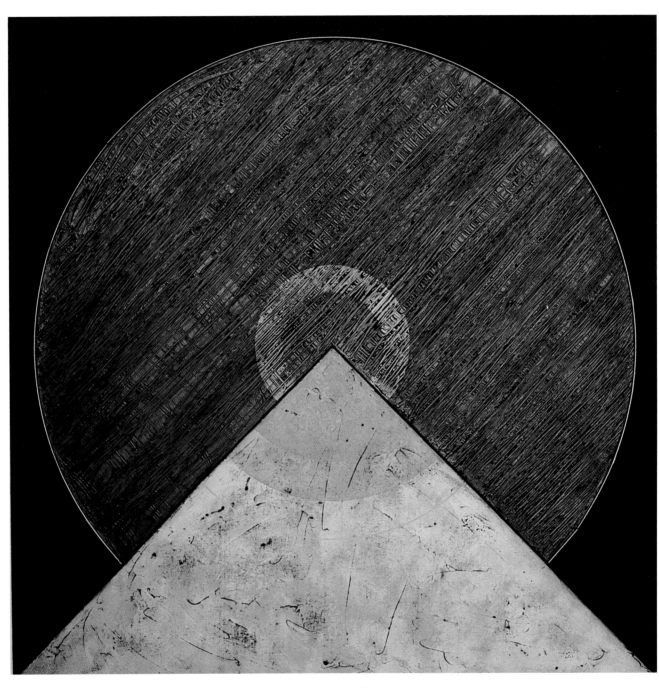

CARBON MOUNTAIN

66" x 66"; Mixed media; 2000

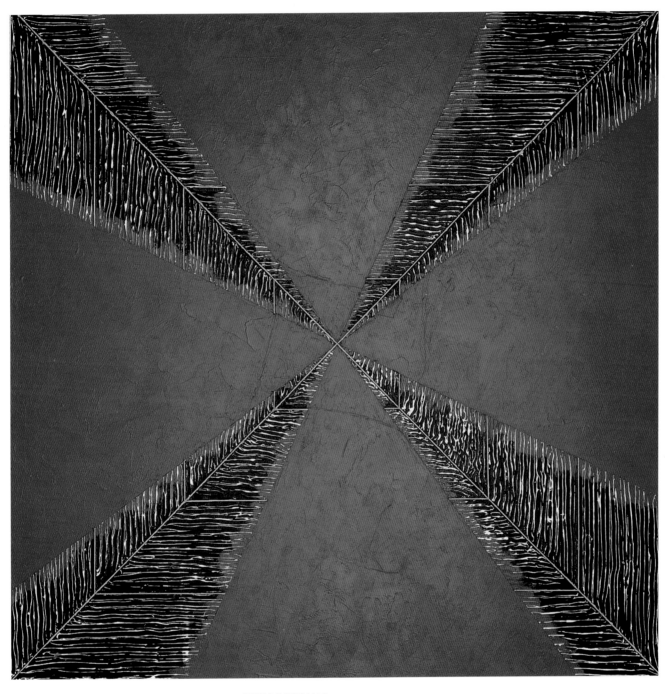

COSMIC DREAM I

90" x 90"; Acrylic and wood on canvas; 2001

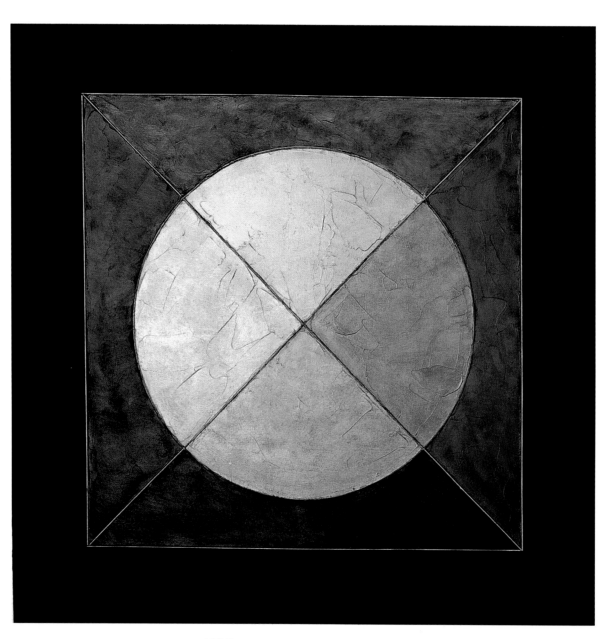

METAL

66" x 66"; Acrylic and wood on canvas; 2000

CIRCLE IN A SQUARE

4" x 48"; Acrylic and sand on canvas; 2000

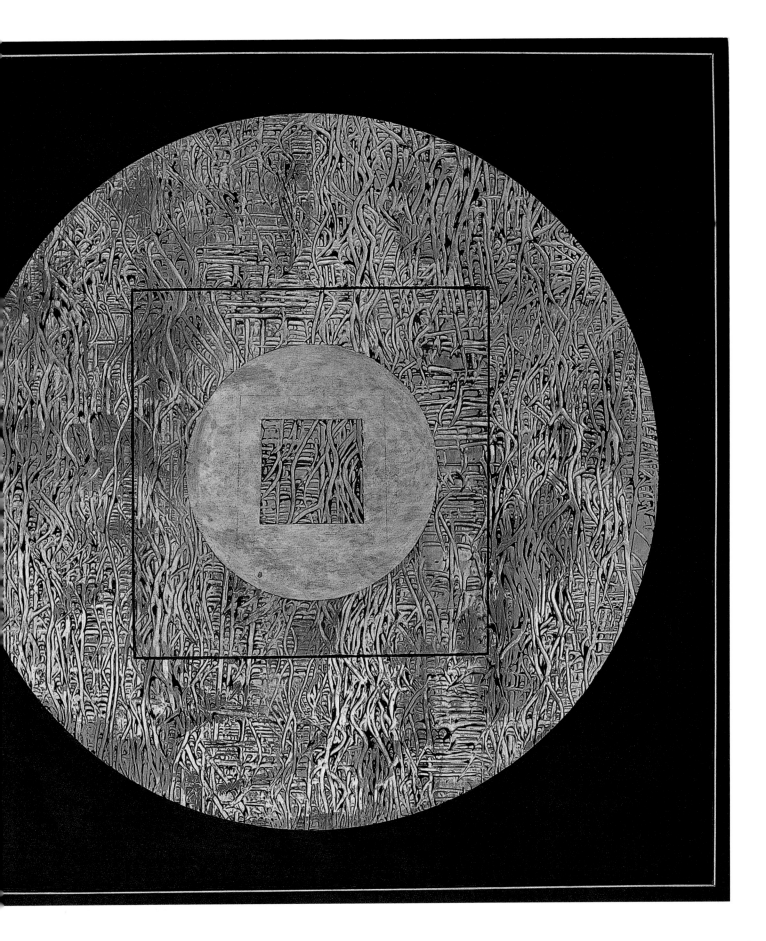

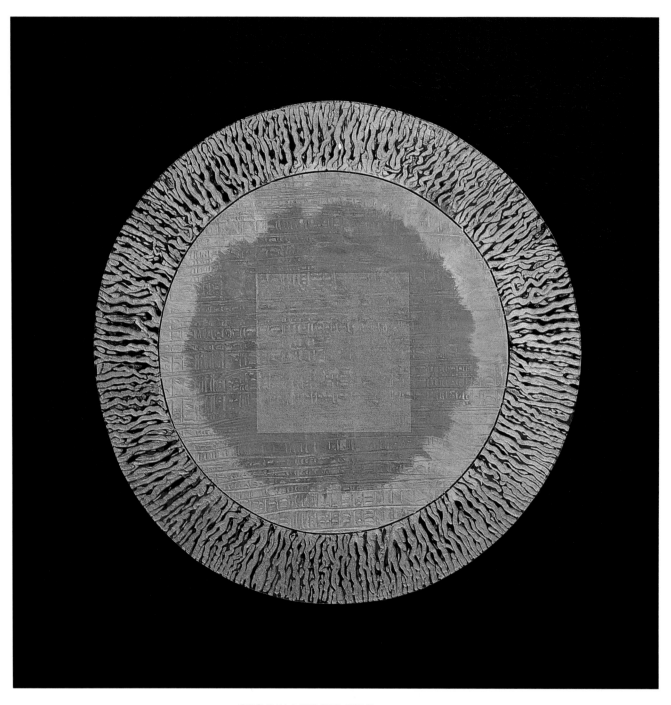

CIRCLE IN A SQUARE GOLD

60" x 60"; Acrylic and sand on canvas; 2000

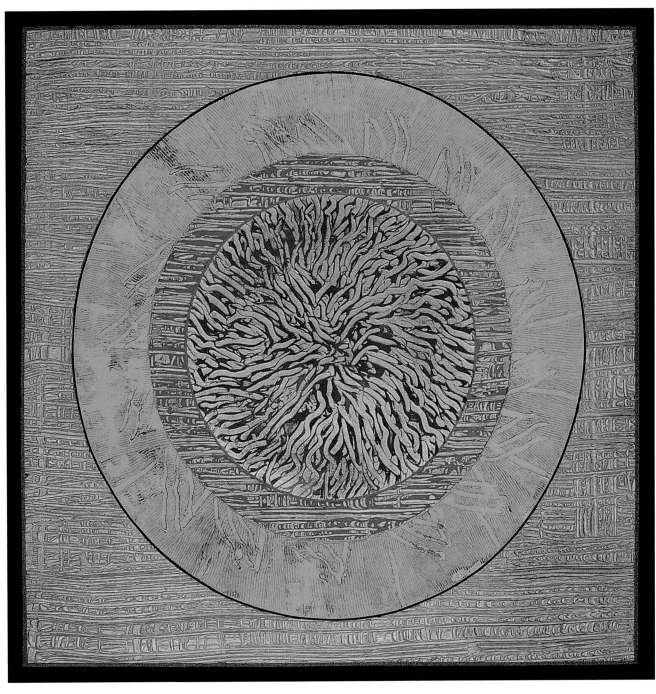

JADE

48" x 48"; Acrylic and silicone carbonate on canvas; 2001

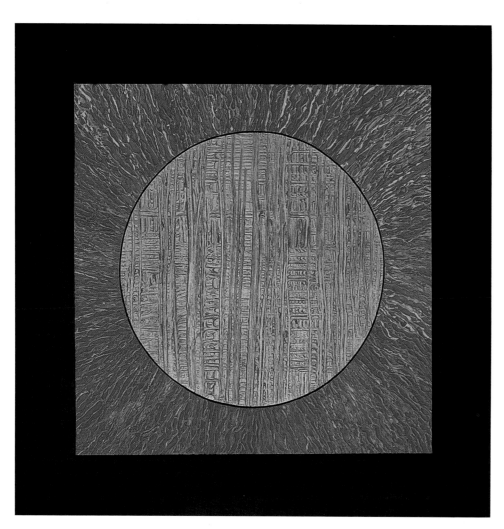

FIRE MANDALA

48" x 48"; Acrylic on canvas; 2000

GONG

72" x 72"; Acrylic, wood, and silicone carbonate on canvas; 2001

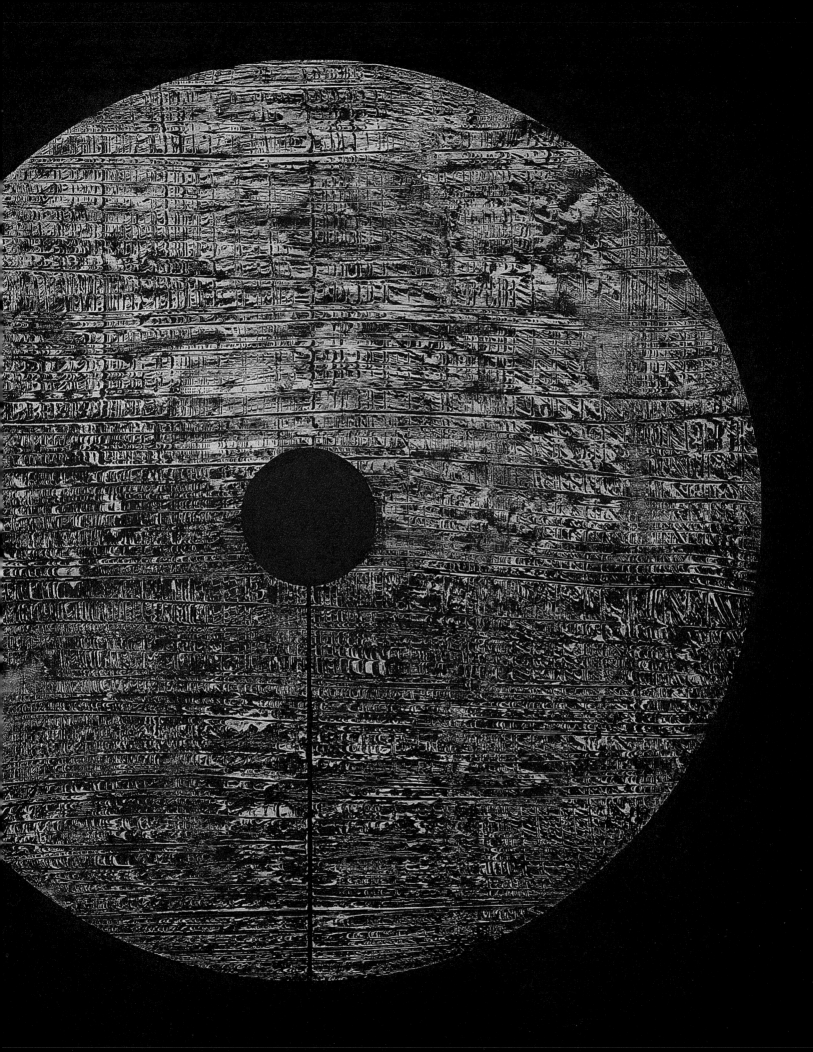

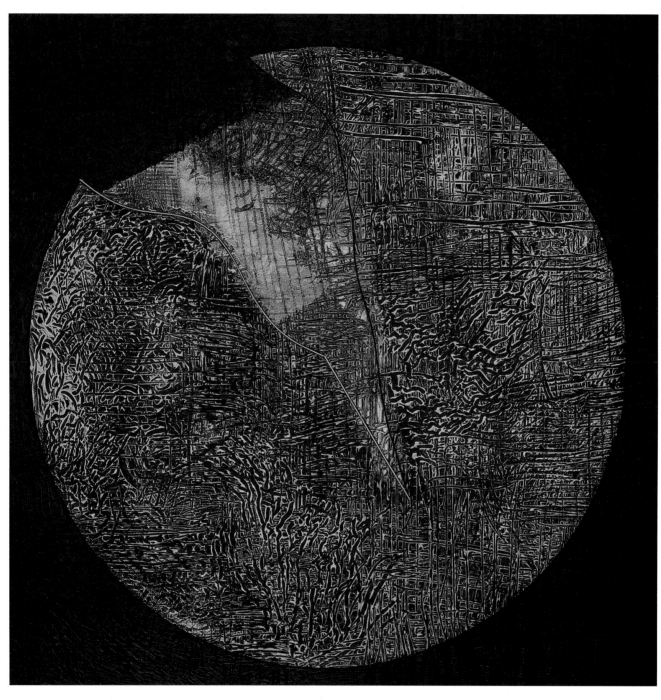

GLOBAL WARNING

66" x 66"; Acrylic and wood on canvas; 2001

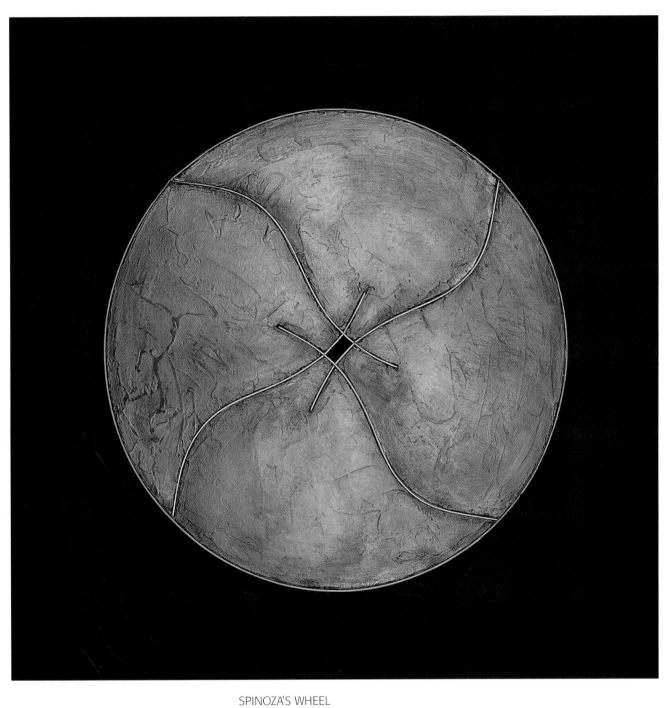

SPINOZA'S WHEEL

55" x 55"; Acrylic and wood on canvas; 2001

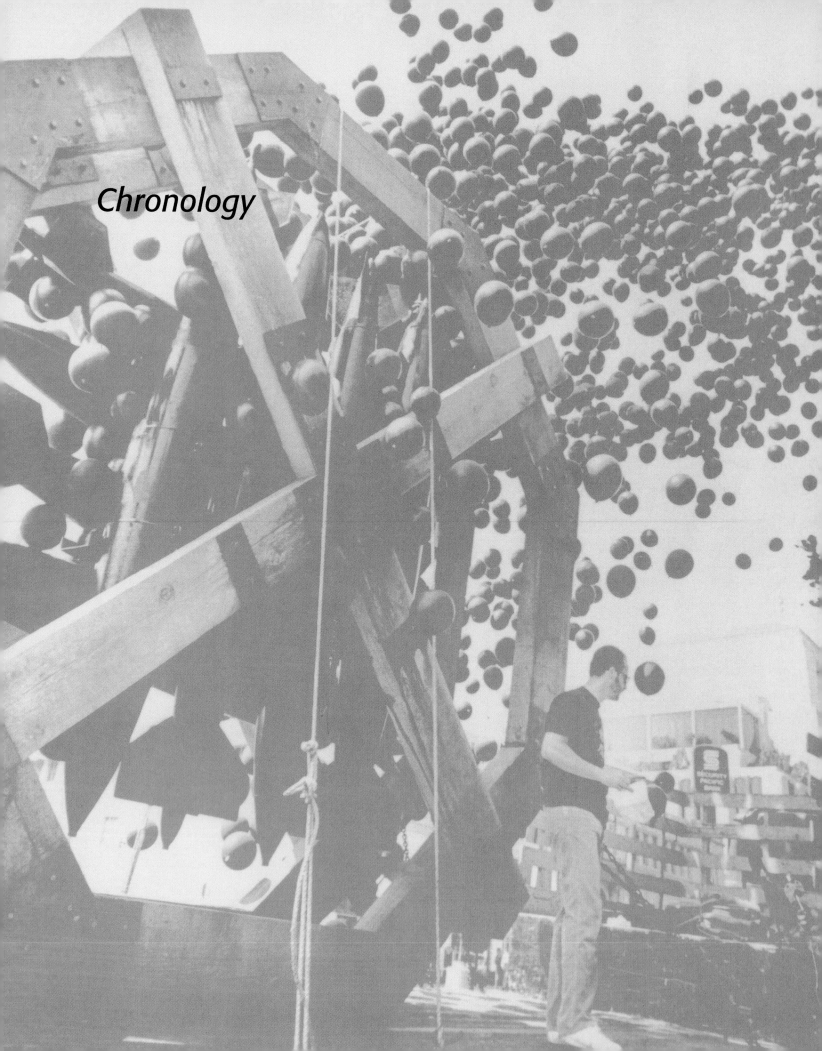

Chronology

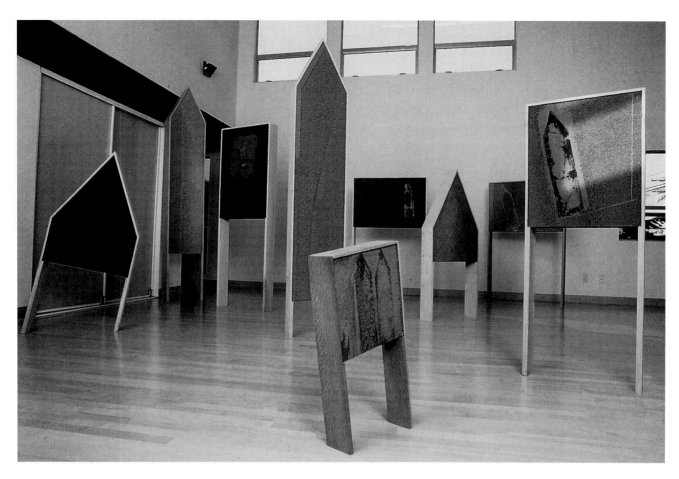

Standing reliefs, Lee Waisler's studio. Painted sculpture, glass, sand, and wood. 1992

Permanent Collections (Selected)

Bibliothèque Nationale, Paris, France

Brooklyn Museum of Art, New York, NY

Cedars Sinai Collection, Los Angeles, CA

Coldwell Banker, Minneapolis, MN

Galleria Civica d'Arte Moderna, Pallazo dei
Diamanti, Ferrara, Italy

Israeli Embassy, Paris, France

Jewish Museum, New York, NY

Karnataka Chitrakala Parishad Museum,
Bangalore, India

Kunsthaus, Zurich, Switzerland

Magnus Museum, Berkeley, CA

Metropolitan Museum of Art, New York, NY

National Gallery of Modern Art, New Delhi, India

Rijksmuseum, Enschede, Netherlands

Sanskriti Kendra Museum, New Delhi, India

Smithsonian Institution, Washington, D.C.

Standard Oil, Chicago, IL

Stanford University Library, Palo Alto, CA

Tel Aviv Museum of Art, Tel Aviv, Israel

The Indian Museum, Calcutta, India

Tibet House, New York, NY

U.C.L.A. Medical Arts Program, Los Angeles, CA

Victoria and Albert Museum, London, England

William Rockhill Nelson Gallery, Kansas City, MO

Yad Mordechai Museum, Ashkelon, Israel

Yad Vashem Museum, Jerusalem, Israel

Yale University Library, New Haven, CT

Solo Exhibitions (Selected)

2001	Lytle Pressley Gallery, Austin, TX
2001	Venice Art Walk, Venice, CA
2000	Dialectica, New York, NY
	Indian Museum, Calcutta, India
	National Gallery of Modern Art, New Delhi, India
1996	Michael Machonochie Fine Arts, London, England
1995	Patricia Correa Gallery, Venice, CA
	1421, Abbot Kinney Gallery, Venice, CA
1994	*Chere*, Couturier Gallery, Los Angeles, CA
1992	Golden West College Art Gallery, Huntington Beach, CA
1990	Sylvia White, Glendale, CA
	Galleria Banco Nuevo, Rome, Italy
1988	Bianca Pilat Gallery, Milan, Italy
	Arturo Schwarz, Galleria Civica d'Arte Moderna, Pallazo dei Diamanti, Ferrara, Italy
	Rijksmuseum, Kunstcentrum Markt Zeuehtien, Enschede, Netherlands

1987	Social and Public Art Resource Center, Santa Monica, CA
1986	Sepulveda Unitarian Universalist Society, Los Angeles, CA
1985	*Under the Mushroom*, Museumplein, Amsterdam, Netherlands, Los Angeles, Santa Cruz, Santa Monica, CA. Atomic Test Site, NV
1983	*The Fabrik*, Hamburg, Germany
	Bomb Cage, Los Angeles, CA
	The Nickle Arts Museum, Calgary, Canada
1981	*Living Room*, Downtown Gallery, Los Angeles, CA.
	Traction Gallery, Los Angeles, CA
1979	Carl Schlossberg Fine Arts, Los Angeles, CA
	Stoneybrook College, Long Island, NY
1978	Hooks-Epstein Galleries, Houston, TX
	Prince Arthur Galleries, Toronto, Canada
1976	Magnus Museum, Berkeley, CA
1973	Kunstsalon Wolfsberg, Zurich, Switzerland
	Diogenes International Gallery, Athens, Greece
	Lumley-Cazalet, London, England
1972	Welna Gallery, Chicago, IL
	Phyllis Lucas Gallery, New York, NY
1971–1968	Ryder Gallery, Los Angeles, CA

Group Exhibitions (Selected)

| 2001 | "Crossroads," Sundaram Tagore Gallery, New York, NY |
| 1982 | "Present Art II," Couturier Gallery, Los Angeles, CA |

1992 "Three California Artists," Sun City Art Museum, Sun City, AZ

"The Figure: Fact, Fiction, and Fragment," Century Gallery, Los Angeles, CA

"The 224th Exhibition," Royal Academy of Arts, London, England

Brand Library Art Gallery, Los Angeles, CA

The Seattle Art Fair, Seattle Westin Hotel, Seattle, WA

1991 ART/LA 91, Los Angeles Convention Center, Los Angeles, CA
"New Connections," Mount San Antonio College, Walnut Creek, CA

C.S.U. San Bernardino, San Bernardino, CA

Boritzer/Gray Gallery, Santa Monica, CA

"Contemporary Artists," Contempo Westwood Center, Los Angeles, CA

Bibliography (Selected)

2000 Mordechai, Omer; *The Vera, Silvia and Arturo Schwarz Collection of Contemporary Art.* A catalogue published by the Tel Aviv Museum of Art.

1998 Green, Charles; Malik, Keshav; Raine, Kathleen. *Waisler and Malik*, Edwin House Publishing, Inc., mixed media on paper by Lee Waisler Malik, Keshav. "Lee Waisler—Gravitating to India." *Span,* September/October 1998. New Delhi, India, page 25

1997 Malik, Keshav. "Union of Art and Heart," *Times of Delhi*, June 1997, New Delhi, India, page 1

1992 Donahue, Marlena. "Lee Waisler," *Visions Magazine*, June 1992, Los Angeles, CA

1991 Donahue, Marlena. "Art Now," *The Christian Science Monitor*, 7 November 1991, page 17

Lee, Sung-Man. *The Design Journal # 42*, page 72

1989 Wendon, John. *Essence and Ends*, etchings by Lee Waisler

1987 Schwarz, Arturo. *Bed Stories*, published by Lee Waisler. Etchings by Beatrice Wood

Primo Levi Homage, 1986–1987. Etchings by Lee Waisler.

1986 Rosten, Norman. *Connections*. Etchings by Lee Waisler. Preface by John Hollander. A portfolio published by Carl Schlossberg, Los Angeles.

Documentaries

Citizen Artist—A Lee Waisler Documentary. Produced by Martin Perlich, 17 May 1983

Beatrice Wood. A video documentary donated for research to the Archives of American Art, West Coast Area Center, M.H. deYoung Museum, San Francisco, CA

Media Coverage (General)

1983 *Stern* Magazine, Hamburg, Germany, July 1983

Last Issue, "Citizens, Artists, Agents of Mechanism X," Blake Brooker, November 1983

1982 *Images & Issues* Magazine, Spring 1982

California Magazine, January 1982

1981 *TV Guide*, January 1981

Playboy Magazine, October 1981

Houston Chronicle, "Poet-Artist Pairing Is Happy Combination," Charlotte Moser

1975 *Southwest Art*, "Lee Waisler's Insight Into Social Conditions," Judith Samuel Glass, September 1975

1973 *The Art Gallery Magazine*, "Where New York," October 1973

1972 *Arts* Magazine, September/October 1972

Where New York Magazine, New York City, 14 October 1972

Articles Regarding Bomb Cage *Protest/Performance in Germany, July–August 1983 (Selected)*

Kultur, Hamburg

Hallertauer Zeitung, Mainburg

Landauer Zeitung, Landau

Landshuter Zeitung, Landshut

Straubinger Tagblatt, St. Aubinh

chamer Zeitung-furter Chronik, Cham

Dingolfinger Anzeiger, Dingolfing

Donau-Post, Worth

Welt Der Arbeit, Koln

Kieler Rundschau, Kiel

Vilsbiburger Zeitung, Vilsbiburg

Hanauer Anzeiger, Hanau

Suddeutsche Zeitung, Munich

UZ Unsmere Zeit, Neuss

Frankenpost, Hog

Marktrewitzer Tagblatt-Frankenpost, Marktrewitz

Muchberg-Helmbrechtser Zeitung, Hof

Kulmbacher Tageblatt, Hof

Selber Tagblatt, Selb

Harzkurier, Bad Sascha

Harzkurier Herzberger Zeitung, Herzberg

Sudhannoversche Volzkeitung, Duderstadt

northheimer Neueste Nachrichten, Northheim

Mundener Allgemeine-Mundener Kurier, Munden

Frankenberger Allgemeine, Kassel

HNA Hessische Allgemeine, Homburg

HNA Hessische Allgemeine, Hofgeismer

HNA Hessische Allgemeine, Kassel

HNA Hessische Allgemeine, Schwalm

HNA Hessische Allgemeine, Rotenburg

Herfelder Zeitung, Bad Hersfeld

Kurier Am Sonntag, Bremen

Die Tageszeitung, Berlin

Fuldaer Zeitung, Fulda

Acher-und buhler Bote, Buhl

Oldenburgische Volkszeitung, Vechta

Aachener Nachricheten, Aachen

Westfalischer Anzeiger-Westfalischer Kurier, Hamm

Oxmox, Hamburg

Esslinger Zeitung, Esslingen

Vlothoer Anzeiger, Vlotho

Hamburger Rundschau, Hamburg

Kieler Rundschau, Kiel

Articles Regarding Living Room Protest/Performance 16 May 1982 (Selected)

Daily News, Los Angeles, CA

Herald Examiner, Los Angeles, CA

Images & Issues Magazine, Los Angeles, CA

United Press International, Los Angeles, CA

We Magazine, Los Angeles, CA

Radio Coverage of Living Room Protest

Los Angeles:

> KMET
>
> KRTH
>
> KLOS
>
> KPFK

United Press International Radio

National Broadcasting Corporation, National Radio

Associated Press, National Wire Service

Television Coverage of Living Room *Protest*

Los Angeles:

> KNXT, Channel 2
>
> KNBC, Channel 4
>
> KTLA, Channel 5
>
> KTTV, Channel 11

Entertainment Tonight, National Syndication

Associated Press, National Wire Service

Cable News Network, National Network

The Sunday Show, KNBC, Channel 4, Los Angeles, CA

Articles Regarding Target L.A. Performance/Sculpture (Selected)

Herald Examiner, Los Angeles, CA

Los Angeles Times, Los Angeles, CA

Daily Valley News, San Fernando Valley, CA

Santa Monica Evening Outlook, Santa Monica, CA

Copley News Service, Wire Service

Herald Tribune, Paris, France

Radio Coverage of Target L.A.

Los Angeles:

> KMET
>
> KRTH
>
> KLOS
>
> KPFK

Television Coverage of Target L.A.

Los Angeles, 16 September 1981:

> KABC, Channel 7
>
> KOOP, Channel 13
>
> KTTV, Channel 11
>
> KHJ, Channel 9

"Two on the Town," an interview entitled "Art Attack," aired on CBS, Channel 2, 27 January 1982

Articles Regarding Times
Protest, 20 May 1981 (Selected)

The Arizona Republic, Phoenix, AZ

The Chicago Sun-Times, Chicago, IL

Chicago Tribune, Chicago, IL

Cincinnati Inquirer, Cincinnati, OH

Dallas Time Herald, Dallas, TX

The Detroit News, Detroit, MI

The Evening Bulletin, Philadelphia, PA

Evening Tribune, San Diego, CA

Houston Chronicle, Houston, TX

The Kansas City Times, Kansas City, MO

La Opinion, Los Angeles, CA

The Light, San Antonio, TX

The Los Angeles Herald Examiner, Los Angeles, CA

Los Angeles Times, Los Angeles, CA

Los Angeles Times, Conrad Syndicated Cartoon, Los Angeles, CA

The Miami Herald, Miami, FL

New York Daily News, New York, NY

The News, San Antonio, TX

The Oakland Tribune, Oakland, CA

The Oregon Journal, Portland, OR

Philadelphia Daily News, Philadelphia, PA

Rocky Mountain News, Denver, CO

St. Paul Pioneer Press, St. Paul, MN

The Salt Lake Tribune, Salt Lake City, UT

San Francisco Chronicle, San Francisco, CA

San Jose Mercury, San Jose, CA

Star, Toronto, Ontario, Canada

The Washington Post, Washington, D.C.

The Washington Star, Washington, D.C.

John Hollander, Sterling Professor of English at Yale University, has received many awards and distinctions during his career, such as the Bollingen Prize for Poetry in 1983 and a MacArthur Fellowship in 1990. Mr. Hollander has published twenty-one collections of poetry, several books of criticism, and is a contributor to such magazines as *The New Yorker*, *Commentary*, *The Paris Review*, and *Esquire*.

Gayatri Patnaik is an editor at Palgrave, an imprint of St. Martin's Press, where she works in Religion as well as Latino/Latin American Studies. A graduate of the New School for Social Research, Ms. Patnaik has authored and edited two books and also writes book reviews. She lives and works in New York City.

Arturo Schwarz has lectured at universities and art academies around the world, and has curated such major art exhibitions as the Venice Biennial and the São Paulo Biennial. Known as an art historian, essayist, and poet, Arturo Schwarz has authored over twenty-eight collections of poems and thirty books, including standard monographs on André Breton, Man Ray, and Marcel Duchamp. A member of the New York Academy of Science, Arturo Schwarz received the Diploma of First Class, with a gold medal for outstanding merits in Culture and the Arts from the Italian president in 1998.

Margaret Sheffield is a teacher and writer. She has published art criticism in *The New York Times*, *Art in America*, *Arts*, *Art News*, *Connoisseur*, *Town & Country*, *Artforum*, and *Sculpture*. She is presently writing a book on modern sculpture.

Sundaram Tagore is a curator and a gallerist who focuses on East-West dialogue. He was previously a director at Pace Wildenstein in New York, and has advised and worked with many international organizations, including the Peggy Guggenheim Foundation, Venice, Italy; the Metropolitan Museum of Art, New York; the Museum of Modern Art, New York; the United Nations; and the National Gallery of Modern Art, New Delhi. He has published articles in numerous magazines, including *Art News*, *Art & Antiques*, *Asian Art News*, *Arts Asia Pacific*, and *The Times of India*.

This catalogue has been published
in conjunction with an exhibition

Crossing Boundaries

at the Sundaram Tagore Gallery, New York

First published in India
in 2002 by
Mapin Publishing Pvt. Ltd.

Simultaneously published in the
United States of America
in 2002 by
Grantha Corporation
80 Cliffedgeway, Middletown, NJ 07701

in association with

Sundaram Tagore Gallery
137 Greene Street, New York, NY 10012 USA
Tel: 212-677 4520 • Fax: 212-677 4521
email: gallery@sundaramtagoregallery.com

Distributed in North America by
Antique Collectors' Club
Market Street Industrial Park
Wappingers' Falls, NY 12590
Tel: 800-252 5321 • Fax: 845-297 0068
email: info@antiquecc.com
www.antiquecc.com

Distributed in the United Kingdom, Europe
and the Middle East by
Art Books International Ltd.
Unit 14, Groves Business Centre, Shipton Road
Milton-under-Wychwood, Chipping Norton
Oxon OX7 6JP UK
Tel: 01993-830000 • Fax: 01993-830007
email: sales@art-bks.com
www.artbooksinternational.co.uk

Distributed in India by
Mapin Publishing Pvt. Ltd.
Ahmedabad 380013 India
Tel: 79-755 1833/ 755 1793 • Fax: 79-755 0955
email: mapin@icenet.net
www.mapinpub.com

Distributed in Asia by
Hemisphere Publication Services
240 MacPherson Road
#08-01 Pines Industrial Building
Singapore
Tel: 65-741 5166 • Fax: 65-742 9356
email: info@hemisphere.com.sg

Text © as listed
Photographs © as listed

ISBN: 81-85822-94-8 (Mapin)
ISBN: 1-890206-34-2 (Grantha)
LC: 2001094611

Design by: Paulomi Shah / Mapin Design Studio
Processed by Reproscan, Mumbai
Printed by Tien Wah Press, Singapore

Caption frontispiece:

AUTOBIOGRAPHY

78" x 66"; Acrylic, glass, sand, and wood on canvas; 1998
Fred and Beth Singer Collection